SECRET
DORKING

Eddy Greenfield

AMBERLEY

First published 2021

Amberley Publishing
The Hill, Stroud
Gloucestershire, GL5 4EP

www.amberley-books.com

Copyright © Eddy Greenfield, 2021

The right of Eddy Greenfield to be identified as the
Author of this work has been asserted in accordance
with the Copyrights, Designs and Patents Act 1988.

ISBN 978 1 3981 0468 6 (print)
ISBN 978 1 3981 0469 3 (ebook)

British Library Cataloguing in Publication Data.
A catalogue record for this book is available from the
British Library.

Origination by Amberley Publishing.
Printed in Great Britain.

Contents

Introduction

As I posited in the introduction to my previous book, *Secret Arundel*, the word 'secret' usually conjures up definitions of something being known only to a select few, and that if something is truly secret then it would not really be possible to write about. This means, of course, that in order to write a book with 'secret' in its title, a looser, more liberal definition of the word had to be used, one that seeks to uncover what is perhaps largely forgotten from popular memory, or not widely known about today.

In order to do this, I have once again sought to avoid subjects that have already been written about elsewhere and instead found stories that show a different side to the people and events that have given the town such a diverse history. As with many towns and villages, you only have to scratch a little beneath the surface to uncover the more unusual, murkier and mysterious side to this beautiful market town in the Surrey hills.

This book will take you on a journey deep into Dorking's long and fascinating past, through topics as diverse as criminal and military history to social and modern history. We will meet some of the town's murderous inhabitants, workhouse inmates and a *Titanic* victim. We will explore the secrets beneath the streets, examine the role of the town's emergency services and investigate how one famous resident tried to make Dorking a very dark place indeed. There will be tales of scandals, strange events and personal sacrifice – I hope that you will find it all just as interesting as I have.

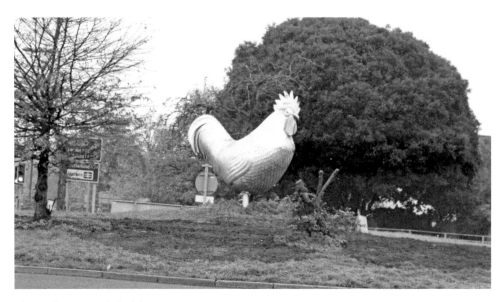

The Dorking – symbol of the town.

Dotted throughout the book will be references to historic sums of money. Today these can be quite meaningless without a modern-day comparison to give perspective as to what these sums actually represented: what was one shilling worth in 1857? What about in 1925? As such, I have included the modern-day equivalent in brackets immediately after each occurrence based upon the National Archives old currency converter, which is correct up to 2017.

DID YOU KNOW?
The Goodwyn's council estate has been praised as 'unusually good' and 'elegant' by the esteemed architectural historians Nairn and Pevsner.

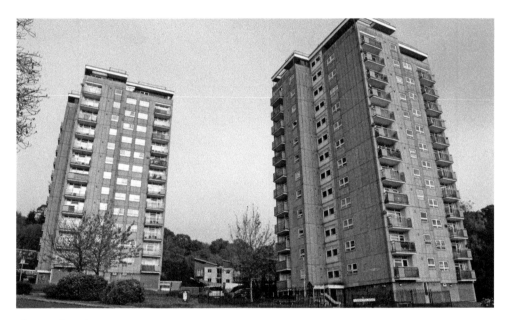

The Goodwyn's estate.

The trickiest part of writing this book was obtaining all the relevant illustrations. Owing to the high concentration of private roads in Dorking and the extensive National Trust property bordering the town, it has been a metaphorical minefield of determining what could and could not be photographed. Furthermore, permissions to obtain desired photographs were not forthcoming in many cases and it has therefore resulted in near-constant revisions to the list of illustrations almost from the outset. This was further hampered by the impact of the Covid-19 virus, which, at the time of making the final edits to this book (March 2020), is presenting even more restrictions to obtaining illustrations. With all this in mind I wish to offer my most grateful thanks to the following for their

kind assistance in procuring and/or supplying photographs: Jean Ward and Sam Dawson at Dorking Museum, Paul Gillett, Colin Smith, David Howard and Gareth James. I hope that the illustrations used in this book will be satisfactory to you, the reader. Nonetheless, it has still been a pleasure to write this book and I hope that you will thoroughly enjoy the journey that you are about to take through Dorking's history, and maybe discover one or two things that may shock or surprise you!

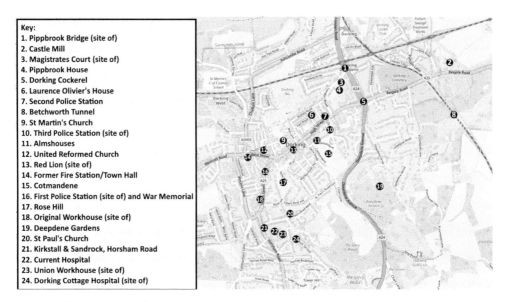

Key:
1. Pippbrook Bridge (site of)
2. Castle Mill
3. Magistrates Court (site of)
4. Pippbrook House
5. Dorking Cockerel
6. Laurence Olivier's House
7. Second Police Station
8. Betchworth Tunnel
9. St Martin's Church
10. Third Police Station (site of)
11. Almshouses
12. United Reformed Church
13. Red Lion (site of)
14. Former Fire Station/Town Hall
15. Cotmandene
16. First Police Station (site of) and War Memorial
17. Rose Hill
18. Original Workhouse (site of)
19. Deepdene Gardens
20. St Paul's Church
21. Kirkstall & Sandrock, Horsham Road
22. Current Hospital
23. Union Workhouse (site of)
24. Dorking Cottage Hospital (site of)

Key sites. (OpenStreetMap)

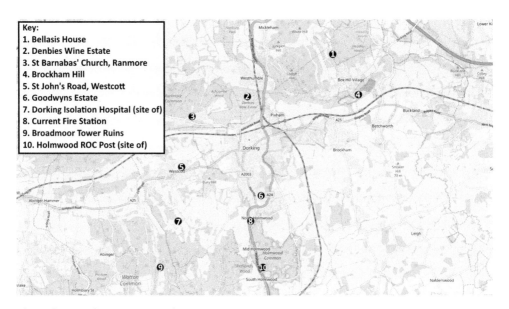

Key:
1. Bellasis House
2. Denbies Wine Estate
3. St Barnabas' Church, Ranmore
4. Brockham Hill
5. St John's Road, Westcott
6. Goodwyns Estate
7. Dorking Isolation Hospital (site of)
8. Current Fire Station
9. Broadmoor Tower Ruins
10. Holmwood ROC Post (site of)

The wider area. (OpenStreetMap)

1. Dark Dorking – Chesterton and the BUF

Dorking was exposed to fascism quite late, especially when compared to the rising popularity in other nearby towns such as Redhill/Reigate and Horsham, which had both established branches of the British Union of Fascists by late 1933. This changed for Dorking in 1936 upon the arrival of the journalist Arthur Kenneth Chesterton (the cousin of renowned author and former candidate for sainthood G. K. Chesterton).

Chesterton had developed a close relationship with Oswald Mosley, joining the BUF in late 1933 and rapidly rising to become the national director of propaganda. He was a regular contributor to the fascist newspapers and also a prominent public speaker for the BUF, often using his platform to spread his vile anti-Semitic beliefs. By 1936, Chesterton and his wife had moved down to Dorking. Interestingly, Doris (contrary to her husband) was a socialist and ardent pacifist who became a member of the Dorking committee of the Peace Pledge Union. Not only did this create the rather ironic situation of husband and wife being key members of two vastly opposing organisations, but the Peace Pledge Union was deeply resented by the BUF; in fact, F. Clinton (of Coast Hill Cottage, Westcott) launched a direct attack on the Dorking PPU committee in the 10 April 1937 edition of *Blackshirt*, by which time A. K. Chesterton was editor of the newspaper.

Coast Hill Cottage, formerly home to a key local blackshirt.

Prior to 1936 fascist activity was almost non-existent in Dorking, and if it were not for Chesterton the blackshirts could well have left the town alone. The only previously recorded mention of any sort of BUF activity was on 12 May 1935 when red, white and blue paper was pasted across the windows of the Co-operative Society's shop in High Street in protest at the society's apparent decision to not celebrate the king's jubilee week. Other Co-operative Society premises in the district were similarly vandalised by the BUF to a greater extent, and Dorking got off quite lightly. For example, one shop in Guildford had the window emblazoned with a large swastika and BUF insignia in sticky red paint.

Chesterton acted as a draw for the BUF to Dorking, including a personal visit by Mosley to his home at Sandrock, Horsham Road, in September 1936. Then, in November 1937, ten members of the Streatham branch descended on Dorking adorned with fascist banners and flags to commence a propaganda hike from the town to Box Hill. They repeated this action again on 12 December.

In 1938, the Chestertons had vacated to East Molesey (No. 13 Hampton Court Parade to be exact), but activity still continued to grow in Dorking. In February 1939 the Rotary Club invited an official of the BUF to address a meeting, creating much controversy at the time. A month later the BUF hosted an evening meal at the Red Lion Hotel with Captain Donovan (the BUF's assistant director-general) as guest speaker. This was to be the largest fascist event held in Dorking and almost fifty members attended, a quarter of which were women. The *Dorking and Leatherhead Advertiser* summarised Captain Donovan's speech as 'not so much an exposition of the Fascist policy, but rather a lecture to young Fascists, pointing out to them the responsibilities, the privileges, and the tasks of membership of the British Union'. In a speech urging members to fully sign up to the 'length, the

Site of the Co-operative Society, attacked by blackshirts in 1935.

The ornate spires of Sandrock, Chesterton's former Dorking home.

height and the breadth of National Socialism [Nazism]', which must disregard any notions of 'moderation and respectability', he went on to praise the 'dignified, inspired and inspiring leadership' of Hitler and Mussolini, promising that Mosley would follow in their footsteps. The speech ended with a gramophone recording of Mosley followed by the national anthem, during which all members enthusiastically gave the fascist salute. Popularity of the BUF declined fairly rapidly after mid-1939 as war with Germany looked increasingly likely, but Chesterton managed to avoid internment, spending the remainder of his life founding a succession of fascist parties, pressure groups and newspapers, the last of which, the National Front, was founded just six years before his death in 1973.

Fascist activity in Dorking went quiet and for almost two decades the political atmosphere remained settled. However, in 1962 the news broke that a new far-right organisation had been using the area as a base of operations. This was in the form of Spearhead – a paramilitary arm of the National Socialist Movement, which used Hitler's stormtroopers as the model for its organisation. The unit was led by Colin Jordan, who had split from the BNP to form his National Socialist Movement (NSM) on 20 April 1962 – Hitler's birthday – after he had clashed with other BNP leaders, whom he accused of not being Nazi enough.

At the trial of the NSM leaders in August 1962, it was stated that Spearhead members were issued with a uniform and their purpose was to undertake so-called 'special tasks', being required to attend weekly meetings for physical training and indoctrination. Unsurprisingly, the unit had drawn the attention of the Special Branch for some time prior to the men's arrest.

During April and May 1962, Spearhead members undertook military-style field exercises close to Broadmoor Tower, near Leith Hill, dressed in grey shirts and jackboots,

Site of the former Red Lion Assembly Rooms.

with one of the men even sporting a German army helmet. Miss Olive Elsie Smith, who lived in a cottage close to the tower, was a witness at the men's trial. She testified that at the end of March two men – one of whom she identified as Jordan – had called by her home and enquired about camping facilities in the area; soon after, on 8 April, about a dozen uniformed men were seen 'dashing in and out of the undergrowth' near her cottage during the course of three or four hours.

DID YOU KNOW?
The last attempt to make Dorking a fascist stronghold was at the 1964 general election when the Patriotic Party stood a candidate for Dorking. This was one of Chesterton's splinter groups, which was originally called the True Tories before being renamed for the 1964 election. They secured just 476 votes, coming in last place. The party later merged into the National Front.

Next in the witness box was Dorking's Detective Courtman, who said that on 8 April he and Inspector West were sent to Broadmoor Tower to observe the activities. He told the court that he spotted a group of men exchanging Nazi salutes and also saluting a flag hoisted at the tower. They then collected small packs from a Land Rover and split into two groups, with one group acting as defenders of the tower and the rest as attackers.

Detective Courtman was followed by Detective Inspector Trowel, who informed the court that after the exercise there were many loud shouts and cheers of '*Sieg Heil*' and then the Horst Wessel song was sung (the official anthem of the German Nazi Party), and testified to overhearing many anti-Semitic and racist slurs. He also revealed that among the men was George Lincoln Rockwell, the founder of the American Nazi Party. In all, almost forty people – including a number of women and children – were taking part in the Spearhead camp on that particular day.

2. Dangerous Dorking – Murder and Mayhem

Over the course of almost a century between 1827 and 1924 an astounding seven charges of murder, manslaughter or attempted murder were brought at Dorking. Below is an examination of each case, as well as some particularly interesting examples of other crimes committed at Dorking over the decades.

Killed by a Wagon

On 28 April 1827, Joseph Chaplain was returning from Wandsworth to his farm at Capel with a wagon loaded with dung. By the time he was nearing the outskirts of Dorking, Chaplain was lying asleep on his dung heap as his horses continued on to their destination unguided. As the wagon was crossing over Pippbrook Bridge a child entered the road and was killed instantly as his head was crushed under the wheels. Chaplain was awakened by the incident and was subsequently arrested. He is said to have spoken ill of the child and expressed no sympathy, although several witnesses at his trial gave good character references. Ultimately, Chaplain was found guilty of feloniously killing Charles Halford, aged nine, and he was sentenced to seven years transportation.

The A24 crosses Pippbrook on the site of the original bridge.

Swing Riots

The ongoing impoverishment of the agricultural workers finally blew up into a series of riots against the church, the Poor Law guardians and wealthy farmers in 1830. By late-November the movement reached Dorking, with increasing reports of threatening letters and incendiary attacks on farms in nearby villages.

On 21 November, a large crowd gathered in Woking to negotiate a reduction in tithes, but they were persuaded to disperse and went about their next objective: to liberate some fellow rioters who had been detained at Dorking, and consequently the group headed for the town.

Dorking was again a target on the 24th, when the rioters went from farm to farm demanding an increase in wages and a reduction in tithes. Afterwards, the 500 rioters assembled in the town itself. The magistrates had sworn in all the gentlemen of the town as special constables and had also sent a request to London for soldiers as reinforcements a few days previous. Nonetheless, the rioters discovered that the magistrates and special constables had assembled at the Red Lion and one hurled a large flint through the window, which struck one of the magistrates on the head. As stones smashed every other window in the property, one of the magistrates attempted to read the Riot Act, but it was in vain. By now sixty soldiers had arrived, but not before the rioters had succeeded in breaking into the hotel and grievously wounding the landlord. A general melee ensued, but the soldiers managed to arrest five rioters and dispatched them to London. Six others were also later arrested and sent to Horsemonger Lane Gaol.

Site of the Red Lion Hotel.

Infanticide

It was 18 October 1856 when Superintendent Page paid a visit to the home of John and Martha Abel to arrest their servant, Eliza Brooker. He took her back to Dorking police station to charge her with the murder of her newborn child. In what was a particularly sad story, Eliza – who had worked for the Abels for some five years – had woken up on 12 October and carried out her morning duties as usual. After breakfast she fell ill and Martha sent her to lie down; she checked on Eliza again at 13.30, who by this time was on her feet and dressed and joined the Abels for lunch, appearing to show no ill effects for the rest of the day.

At the police station, Eliza told the superintendent that she had given birth to a child while confined in her room after breakfast. No one else in the house knew that she was pregnant, and fearing that Mrs Abel may hear the noises the baby was making, she hit the child's head on a box and punctured the child's neck with a penknife, placing the body, knife and clothes in the box that was stored in a cupboard. The box remained there until the 14th, when Eliza buried it in the garden.

The coroner's inquest, where the above details were relayed by various witnesses, was initially held at the Bull's Head, but was later moved to the Red Lion on 27 October. On this latter date, Mr Napper, a surgeon, deposed that on the 17th he had visited Eliza to examine her and came to the conclusion that she had not given birth, since upon carefully examining her breasts he did not see any evidence of a pregnancy. On 20 October another surgeon examined Eliza and declared that he was in no doubt that she had given birth. The coroner's jury took just thirty minutes to return a verdict of wilful murder, and the case

Arundel Road, where Eliza Brooker committed her crime.

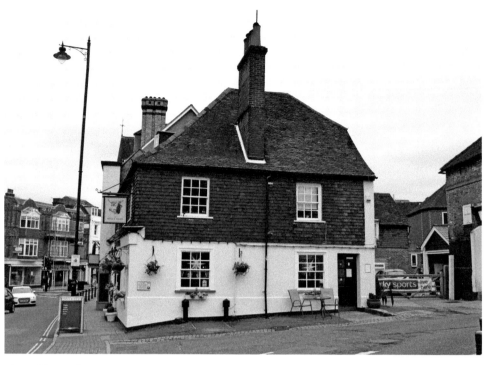

The Bull's Head, scene of an inquiry into infanticide.

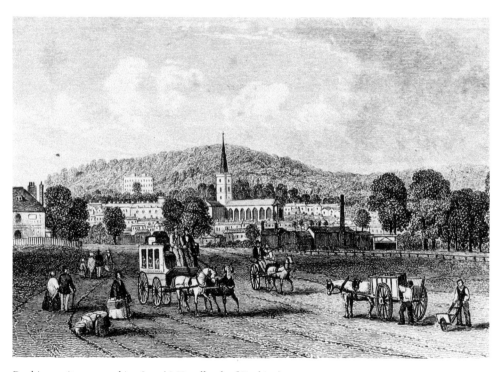

Dorking as it appeared in 1855. (*A Handbook of Dorking*)

was sent for trial. Ultimately, the charge of murder was reduced to one of concealment of birth and Eliza was sentenced to three months imprisonment.

Who Threw the First Punch?

In March 1867 Emma Bax was summoned for an assault upon Emma Bolt on 16 February. The two women's children were playing marbles in Back Lane (now Church Street) when they got into an argument and began to fight. Mrs Bolt accused Bax's son of throwing the first punch and when attempting to separate the boys, she accused Mrs Bax of striking her (Bolt's) son, hitting his head against a wall and then hitting Mrs Bolt. She then pulled Mrs Bolt by the hair and knocked her first into a hedge and then into a muddy puddle. Mrs Bax, however, accused Mrs Bolt of hitting her (Bax's) son and then pulled a large lock of hair from Mrs Bax's head, which she produced in court as evidence. The magistrates concluded that the evidence given was so conflicting as to determine who the aggressor was and that both women appeared equally to blame; they dismissed the case.

Eight months later a similar incident occurred when Eliza Godwin was accused of assaulting Emma Lewcock, of West Square, on 17 October. Mrs Lewcock claimed that as she was going into her apartments Mrs Godwin approached with her sleeves rolled up and punched her in the eye, then dragged her by the hair along a cobbled passage. When Mrs Lewcock got to her feet, Mrs Godwin began tearing at her clothes. Mary Ann Bradley stated that she heard a scream in the passage that morning and saw Mrs Godwin dragging Mrs Lewcock by her hair before striking her on the head. Mrs Godwin, however,

Church Street, formerly Back Lane.

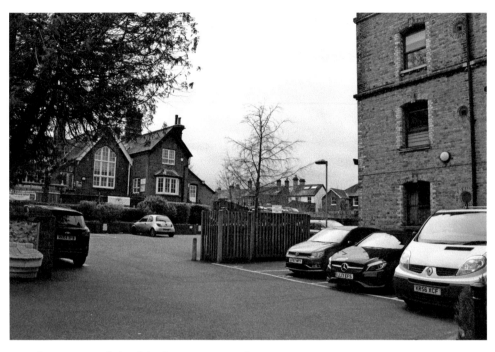

Site of West Square, behind the former Town Hall.

contradicted the events in her testimony by saying that she had gone to ask Mrs Lewcock a question, but that the latter 'flew at me like a cat'. She stated that it was Mrs Lewcock who had tore at Mrs Godwin's dress, not the other way round. Amelia Edwards deposed that she saw Mrs Godwin with a black eye, bruising around her throat and a torn dress and accused Mrs Lewcock of being the aggressor. This time the magistrates decided that Mrs Godwin was solely at fault and fined her 24s (£75.13).

Attempted Fraticide

Alfred William Champion was charged on New Year's Day 1873 with stabbing his brother Frederick (Dorking's postman) in an attempt to kill him on Boxing Day. On the day in question, the two brothers concerned (and two other brothers) met at their mother's house at Spring Gardens. In the evening they all went to a local inn (probably The Star), where the prisoner got into a fight with another man after getting drunk. Frederick told Alfred to return home, whereupon Alfred pulled a knife from his pocket and stabbed his brother. On 28 December, Alfred handed himself into the police and news was awaited as to Frederick's state of health before the case was proceeded with. At first doctors had little hope that Frederick would recover, owing to the extent of the injuries and loss of blood, but by mid-January his condition began to improve. Alfred was before the Surrey Assizes on 26 March on a lesser charge of feloniously wounding his brother with intent to do him grievous bodily harm; he pleaded not guilty. The jury disagreed and found him guilty, but only of unlawful wounding (i.e. without intent) and Alfred was sentenced to twelve months imprisonment with hard labour.

Spring Gardens.

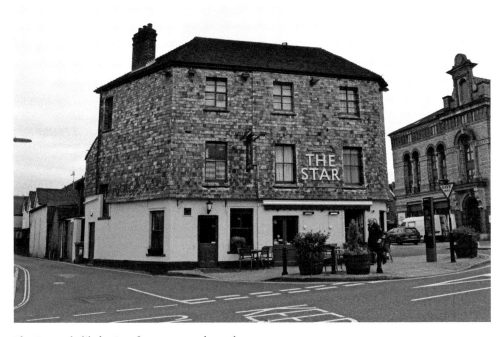

The Star pub, likely site of an attempted murder.

'A Most Brutal Outrage...'

This is how an article in the 30 April 1887 edition of the *Dorking and Leatherhead Advertiser* began when reporting on another attempted murder in the town. This time it was Francis John Davies in the dock, and the scene of the crime was the Black Horse Inn on 11 April 1887.

Davies and Margaret Cummings came to Dorking to hawk primroses. They were known to be regular visitors to the town's numerous public houses and on this evening they entered the Black Horse. Others in the bar overheard the two arguing and Margaret threatening to return to Croydon alone. Davies calmly walked to a door leading to a dark hallway and beckoned Margaret to follow him, which she did. Mrs Arthurs, the landlady, heard screams from the back room and found Davies with his arm around Margaret's neck and a bloodied knife in his hand; Margaret had a stab wound just below her jaw. Davies was about to stab her a second time when Mrs Arthur entered the room and cried for help. Two men from the bar tackled Davies and seized the knife, before pinning him down on the stairs. At that moment Superintendent Lambert was passing by and the landlord called him in. Davies was arrested and taken to the police station while Margaret was conveyed to the cottage hospital.

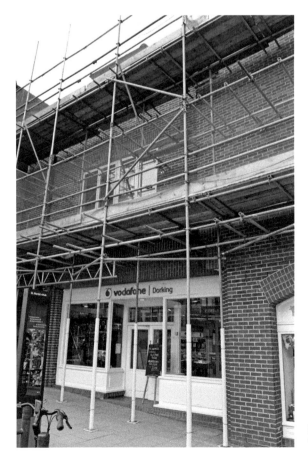

Site of the Black Horse Inn, now the Vodafone shop.

When questioned, Davies openly admitted that he intended to kill Margaret and was brought before the magistrates on a charge of attempted murder. Margaret was by now well enough to attend court – her wound, although deep, had not caused any serious damage. Rather than being a witness for the prosecution, she instead rose to Davies' defence and excused his behaviour by saying that she had behaved badly towards him all day and the pair drank heavily that evening. Davies was committed for trial to the Central Criminal Court where he was found guilty of unlawful wounding and sentenced to three months hard labour.

A Lesson Not Learned

Ellen Wood did not learn her lesson when she was arrested by PC Buckland for being drunk in High Street on 18 July 1896 – she had only been released from prison earlier that same day having served a fortnight for drunkenness in Dorking. She was fined 2s 6 (£9.77), but refused to pay so was sent for another fortnight in the cells.

The High Street, where Ellen Wood was arrested.

The Dorking Sacrilege

A young, eighteen-year-old Walter Fry found himself at the Old Bailey on 9 January 1899 on charges of entering St Paul's Church, Dorking, and stealing the contents of the alms boxes, as well as other thefts at Redhill and Reigate, to which he pleaded guilty. The boy's criminal record was told to the court: on 8 September 1894, he stole money from his father and was ordered to be birched by the Dorking Petty Sessions. A month later he was sent to a training ship for five years having been convicted of another theft. He served only three years before returning to Dorking to live with friends, but his behaviour worsened. For the offence of breaking into the church alone he was sentenced to twelve months hard labour.

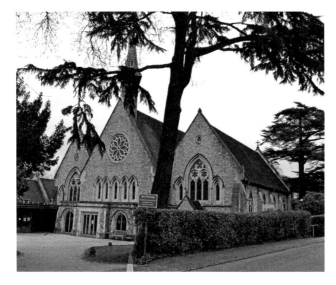

St Paul's Church.

St Paul's Church, *c.* 1855
(*A Handbook of Dorking*)

St Barnabas' Church, Ranmore. (The Voice of Hassocks)

Hampstead Road, scene of an infanticide case in 1903.

In 1884, Henry Turner was tried on a similar charge of breaking and entering St Barnabas' Church, Ranmore, on 30 April. He had since been arrested at Sevenoaks for the same offence at Knockbolt and Chelsfield churches, whereupon he admitted to the Ranmore incident, as well as breaking into the churches at Wotton and Westcott. In total he claimed to have robbed over forty churches and was handed into the custody of Dorking Police.

Another Child Victim

Annie Reynolds had been living in Hampstead Road for just seven weeks when, on 17 February 1903, her husband Sidney left the house to visit his workshop as usual. He went out on an errand and upon returning found his wife in the workshop, who told him 'I have done it.' Confused, Sidney followed Annie upstairs and found the body of their youngest child – his throat cut with a bread knife, which had been dropped close to the body. Annie was arrested and immediately brought before the magistrates that same day.

At the coroner's inquest held at the cemetery, Sidney gave evidence and testified that his wife had been a caring and affectionate mother, but had been in a poor state of mental health since the birth of their son, and her sister had been committed to asylums three times after childbirth. The examining doctor stated that Annie was in a state of 'homicidal monomania, the result of lactational insanity'. The jury returned a verdict of wilful murder and she was committed to the next assizes, being sent to Holloway to await trial.

DID YOU KNOW?
In 1897 there were two separate attempts to derail trains at Dorking. The first, in February, concerned a wooden sleeper and skid pan that someone had placed on the line near Box Hill. It was removed in time before a train hit it. In the second incident in April, a man named Kelly placed a heavy iron platform seat on the line at Dorking. This time a train smashed into the obstacle but thankfully it did not derail.

Thankfully no trains derailed at Dorking, despite several attempts.

On 3 March 1903, Mr Justice Lawrence charged the grand jury on the case and said that there was no doubt that Annie had committed the act and that the question as to her state of mind was of no concern to the case. A true bill was returned and the matter went to trial the next day, where Annie was found guilty of murder, but having been insane at the time. She was ordered to be indefinitely detained in a criminal asylum.

The Westcott Tragedy

The scene that greeted PCs Luff and Steele outside The Cabin pub (now No. 1 St John's Road, Westcott) just after midday on 9 September 1908 was one they wouldn't forget: Emily Fairbrother was seated on a bench outside the pub, her clothes were stained with blood, her throat was heavily bandaged and she was unable to speak. With assistance, she was taken back to her house opposite the pub, where she died within an hour. The police commenced a search of the house and in the cellar found a small, blood-stained shovel, a blood-spattered chopping block and a bloodied razor. In an upstairs bedroom was Emily's

husband, John James Fairbrother, who also had severe cut wounds to his neck. Beside his leg was a large wooden stake, also marked with bloodstains. Large quantities of blood were also smeared up the staircase and across the kitchen floor leading to a wash house outside, as well as on the cellar steps, in the scullery and across the road outside leading to The Cabin. Fresh blood also stained the door to an adjacent bedroom to the one in which John Fairbrother was found. Whatever had happened had been extremely violent. Like a scene out of a horror film, John (being unable to speak) beckoned PC Steele over to him and, gesturing to the floor, he dipped a finger in the pool of blood and wrote a message on the floorboards: 'Razor in cellar. It is all through last Friday'. Taking a piece of paper and a pencil from PC Steele, he continued writing: 'Never have anything to do with that woman; she is a wicked woman'. First aid was administered and Mr Fairbrother was taken to Dorking Cottage Hospital. The coroner's inquest concluded on 2 October, and after hearing the evidence it took the jury just one minute to return a verdict of wilful murder against John Fairbrother, who after killing his wife had attempted the same on himself.

The couple had been married for twelve years, but on the day before Emily's murder she had taken out a separation order at Dorking Magistrates' Court. On the morning of the 9th the pair were heard to be arguing, although nothing more was seen of Emily for a couple of hours until just after midday when a scream was heard, followed by Emily running across the road seriously injured. At the assizes on 26 November, a statement from John Fairbrother was read, stating that he had found his wife hanging in the cellar and cut her down with the razor, before running upstairs and hiding under the bed to escape from a supposed housebreaker who had attacked Emily. The court gave no credence to this statement and was in no doubt that John had attacked Emily with the razor. A true bill was returned and the case went to a full criminal trial the following day.

The former Cabin pub, Westcott.

One of these cottages was the scene of murder!

DID YOU KNOW?
In 1905 a large burglary occurred at Denbies, then the home of Reigate's Conservative MP, the Hon. Henry Cubitt. Entry had been made via the window of a basement toilet and among the many items stolen were wedding presents of Lord Ashcombe, a gold watch, a silver watch, a ball of silver foil, some small pebbles and a caraway seed. The perpetrator, William Gray alias Thomas Fletcher, was sentenced to seven years imprisonment.

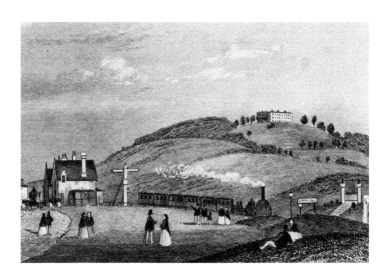

Denbies from the railway, c. 1855. (*A Handbook of Dorking*)

Fairbrother pleaded not guilty and during the seven-and-a-half-hour trial one of the jurors fainted as intimate details of the wounds inflicted on Mrs Fairbrother and the state of the house when the police entered it were given – a scene that one constable described as resembling a slaughterhouse. The jury returned a guilty verdict but pleaded for leniency; the judge nevertheless passed the death sentence. Fairbrother unsuccessfully appealed the verdict, but Emily's brother petitioned the Home Secretary on John's behalf and on 16 December received a response to say that the death sentence had been reprieved to one of life imprisonment in Wandsworth Prison.

Yet Another Child Murder

Daisy and Robert Frank Kelsey lived at No. 5 Archway Place in 1924 and had been married for six years when Daisy gave birth to their first child, a daughter, on 9 May. The marriage was a happy one and Daisy had been in good health until a few months prior to giving birth when she became depressed. On 7 June Robert left for work at 08.00 as usual, but at 08.50 Daisy walked into Dorking police station and made a statement, leading to Superintendent Tamplin paying a visit to the house. A dreadful scene greeted him upon entering the bedroom: on the floor near the bed head was a bucket of water in which Kelsey's four-week-old daughter was submerged head down. Superintendent Tamplin charged Daisy with murder and she was sent to Holloway on remand.

Houses in Archway Place, Dorking.

At the inquest, Robert had difficulty in composing himself and it was some time before he was able to take the oath. He told the jury that he had been to the mortuary to identify his daughter; she hadn't yet been christened and they wanted to name her Sheila. The following day, after more witnesses gave evidence, the coroner addressed the jury, advising them that there were two possible verdicts: one of infanticide if they believed Daisy to have been temporarily 'disturbed', or if they agreed with the medical evidence that she was of sound mind then they must return a verdict of wilful murder. After twenty minutes the jury returned the latter verdict and she was committed to the next assizes.

At the assizes the wilful murder verdict was again returned, but that Daisy was insane at the time. She was sentenced to be indefinitely detained in a criminal asylum.

3. Dutiful Dorking – Emergency Services and Public Institutions

Despite its modest size, Dorking has had a significant number of public service institutions serving and protecting the town over the decades. This chapter will take a look through their long and varied history.

Police Station

Dorking's first police station was sandwiched between Victoria Terrace and South Street, around where the public toilets are today. It had been built in *c.* 1855 with two vaulted cells, but by 1856 this had already become inadequate, as a report in the 27 September 1856 edition of the *West Surrey Times* highlights: 'their faulty construction, inadequacy of area, and total defect in ventilation, are wholly unsuited for the detention of prisoners'. Things only got worse, and when Alfred Cambell was arrested on suspicion of theft, the case created more comment regarding the state of Dorking's cells than on the actual crime. The police station did have one infamous prisoner lodged in its cells, however. Dr Simon François Bernard, a conspirator in the 1858 Orsini Plot to assassinate Napoleon III, was

Site of Dorking's first police station.

housed in the cells on 24 April 1862. He had become 'insane' after accidentally revealing the identities of the other conspirators, resulting in those men being executed. He was taken before the Dorking magistrates on the 25th and was consigned to Wandsworth Lunatic Asylum.

Henry Turner, the serial sacrilegist we first met in the previous chapter, became Dorking's first prison breaker in 1884. The cell doors had a small gap to allow communication with the prisoners and on 24 July Turner somehow managed to squeeze through the gap and follow a passageway leading to the rear door of the building without being seen. Out the back was a high wall, but Turner managed to scale it and gain access up on to Butter Hill, from where he made his escape. One constable spotted Turner climbing the wall and followed him to Rose Hill, but Turner managed to shake off his pursuer and made a clean getaway.

Little had changed at the station and in 1890 it was branded as the 'worst station in Surrey' by the *Dorking and Leatherhead Advertiser*. However, an extension to the station was not feasible and a search for a new site was made. Despite the building being condemned, it took another two years before a new site for a combined police station and courtroom was found in High Street.

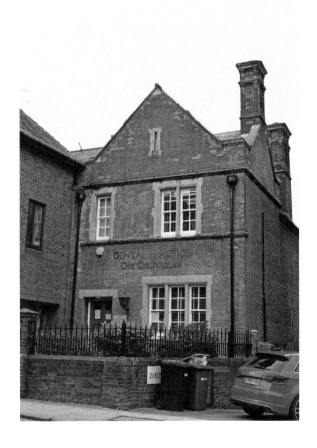

The surviving portion of Dorking's second police station.

Nearing completion in August 1894, the new station and courthouse was opened to journalists for a preview. It was originally topped with battlements, which have since disappeared. Beneath the large courtroom were the four cells and in case of emergencies the basement also included a large 'association cell' capable of holding up to fifty people. The internal passageways were also large enough to allow inmates to exercise during wet weather. The cells were reached via the charge room, which was entered via a Tudor-style arch under the clock tower. A wide staircase led from the cells to the courthouse above, and out the back was a paved exercise yard, which also doubled as a drill square for the constables. At the far eastern end of the building (now the Old Courthouse Dental Practice) was the superintendent's private house and two residences for the constables were allocated at the far western end of the building. The front of the building was enclosed by the still-extant wall and iron railings, while the exercise yard at the back was enclosed by a tall brick wall. The building was completed in January 1895 and Superintendent Alexander, along with PC Boon and PC Oliver (with their families), moved into their new home. The old station was eventually sold to the council in 1904, who wished to demolish it to widen South Street.

The police station's Tudor-style door.

Site of the exercise yard of Dorking's second police station.

Site of Dorking's third police station.

In the 1950s the police vacated the premises and moved into a new, purpose-built station in Moores Road, now the site of Nos 1–2 Avondale Villas. At the northern end of the present Brunswick Walk were three police houses. The second station remained in the hands of the magistrates' court until that also moved into a new purpose-built (and now demolished) building to the north-west of Pippbrook House in the 1970s. Perhaps the biggest claim to fame of Dorking's third, and final, police station was its role in investigating the attempted assassination of Lady Beaverbrook in May 1971. Lady Beaverbrook, widow of the media baron Lord Beaverbrook, resided at Cherkley, a mansion near Leatherhead, when on 3 May 1971 her chauffer spotted a bomb clipped on to the exhaust of her car. The bomb measured more than 6 inches in length and had been designed specifically to attach to a car exhaust, the heat from which would have burnt through a piece of string holding back the detonator. Once the bomb had been removed the car was taken to Dorking police station for examination and Dorking CID was charged with investigating the case, which focused on a trip to London earlier in the day. Ultimately, responsibility for the attempted bombing rested with a group known as The Angry Brigade, which conducted a number of bombings in the UK between 1970 and 1972. Permission was granted to demolish the police station and erect a number of houses in 2012, and the site is now occupied by Brunswick Walk.

Fire Station

Dorking's fire station began life as the Town Hall, but even the story of this building is not so straightforward. In 1862 the town had been without a public hall following the demolition of the old market hall (which had included a small lock-up for felons) near the Red Lion in the High Street in 1813. The then Duke of Norfolk promised a replacement to the ruinous hall, but died shortly after the building had been demolished. Several attempts were then made to erect a replacement, but plans were always thwarted for one reason or another – often for reasons of petty politics and vested interests. However, by 1862 the only sizeable room was attached to the Red Lion Hotel and public demand for a public hall was too loud to ignore any longer; Henry Cubitt, the town's MP, called a meeting to decide on a way forward. A committee was formed to find suitable land for a new town hall.

On 25 November 1871 Mr Cubitt laid the foundation stone of the new public hall at an elaborate ceremony attended by many guests. Part of the stone had been hollowed out and in the space had been inserted copies of *The Times*, the *Standard*, and the *Daily Telegraph*. Once finished it was a large rectangular building a little south of the later replacement hall, which still stands today in West Street. At the front was an open area known as West Square. However, it wasn't all that long before this building started to fall out of favour.

In the 15 October 1887 edition of the *Surrey Mirror*, an anonymous correspondent wrote that he 'cannot conceive a worse "death trap" than the Dorking Town Hall'. His complaint came in light of the Exeter theatre disaster of 5 September 1887, in which a fire, coupled with restricted exits from the auditorium and a panic among the public, resulted in 186 deaths in what still remains the worst theatre disaster in the country. The anonymous writer picked out similar hazards at Dorking, where there was only a single exit that led directly to a staircase with two sharp turns – an issue that often led to congestion after

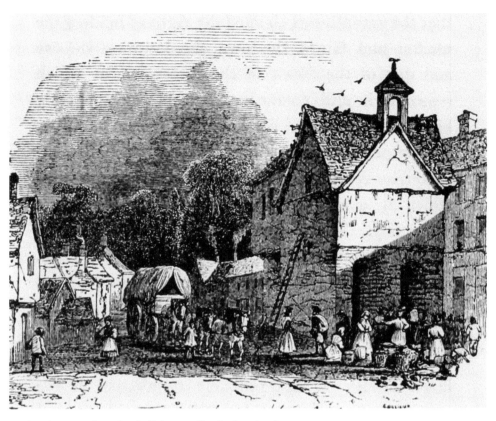

Dorking's original market hall. (*A Handbook of Dorking*)

public meetings had finished there. A second small door was situated by the stage, but this was similarly insufficient, and the windows were a considerable distance above the ground outside.

Someone must have listened, since within a decade a new and improved town hall had been built on the former West Square – the building seen today. Later on, the building became the fire station, and by 1938 Dorking had about sixty firemen on duty. This number swelled upon the outbreak of war in September 1939, when the station became the headquarters of the town's Auxiliary Fire Service. In the last week of August there had been fifty auxiliary firemen signed up, but on the day after war was declared (3 September) this had increased to almost 150. In fact, so popular was the AFS that people were enrolling at a much faster rate than they could be trained for the role; a small number had to be discharged after enrolment owing to the excess numbers, causing some ill-feeling when several of these men had given up their previous jobs in the expectation of becoming a full-time fireman. The number of fire engines also increased, with four new appliances being delivered to bolster the existing equipment before the month had finished.

The station operated at this site until around 1971, and after that eventually became empty. Proposals in 2008 to convert the building into housing was contemplated, but

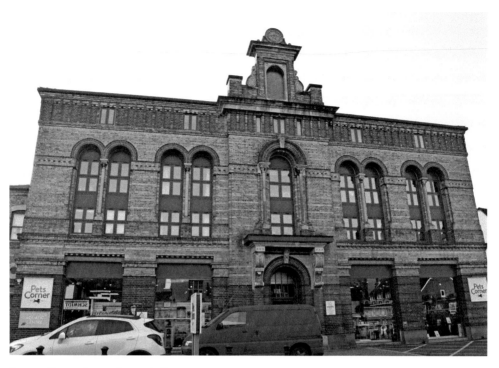

Former fire station and town hall.

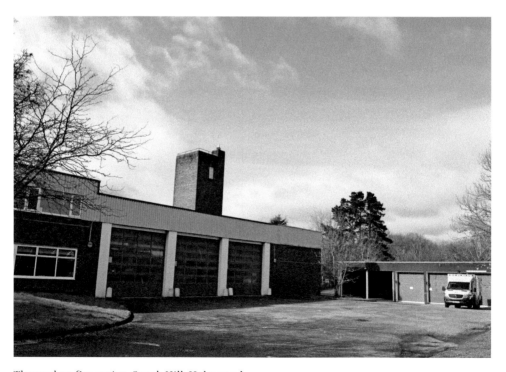

The modern fire station, Spook Hill, Holmwood.

ultimately not proceeded with and today the building has become a pet shop with apartments at the rear. The present, modern fire station is now located just off Spook Hill in North Holmwood.

Workhouse and Hospital

The original workhouse, dating to the late seventeenth century, was situated in South Street, approximately on the site of York House and Old House, and it would seem that the building had previously been the town's original almshouse prior to the new ones being built at Cotmandene in 1677. In 1836 the Dorking Poor Law Union was created and in 1841 the South Street workhouse was relinquished when a new Union Workhouse for 250 inmates was opened on a large plot of land sandwiched between Horsham Road and South Terrace. Maps show that the site consisted of an ornate entrance block and porter's lodge facing Horsham Road, behind which was the H-shaped main block; the two vertical parts would have housed the inmates in separate male and female wards, and the two were joined by the combined chapel and dining hall.

In 1881, a reporter from the *Surrey Mirror* spent a day at Dorking's casual ward and his account, published in the 5 March edition, gives a vivid description of what the place was like. Upon approaching the 'precincts of the prison like pile' a prospective inmate would ring a bell at the entrance block to signal to the porter. Announcing that they would like

Site of Dorking's original workhouse, South Street.

The surviving workhouse entrance block.

to enter the workhouse for the night, they would face a brief interrogation – name, age, occupation, home town. The answers would be written on a slate and the person invited in. Inside, they would have to give up any matches, knives, tobacco and pipes. A man in paupers' uniform would then appear from a dark room with a basket in which the prohibited items were placed. Each man would then be handed a half-pound of bread to sustain him the night, and women would also get a pint of broth. At this point men and women would be separated and taken off to the respective parts of the workhouse. Upon reaching the casual ward, the inmates would be made to strip and enter one of two communal baths, which were only heated during the winter. On this particular night, there were already twenty occupants in the men's casual ward, all housed in twelve isolated cells with a combined total of four wooden benches; once these cells were filled straw would be laid down in the passageway for the remainder to sleep on. At Dorking, the women's ward was unheated, 'but they have a compensation in the shape of a straw mattress to lay upon'. In the morning, the women would be first to breakfast and would receive a half-pound of bread and one and a half pints of gruel. The men, as per the night before, received only bread. The male casuals would then be sent for three hours of hard labour (pumping water, breaking stones or picking oakum) and the women would be made to do the washing, scrubbing or needlework until being released at 11.00. If an individual spent any three nights of a calendar month as a casual, they were forcibly detained as an inmate for three days, in which time they had to pick four pounds of oakum or eight pounds of beaten oakum.

By the 1890s a separate chapel had been built north of the entrance block and in the south-east a separate casual ward had also been erected. On 25 July 1901 a new infirmary block was opened to the east of the main building, marking the beginning of the future for the site as a hospital. It housed beds for thirty men and thirty women, with extra accommodation being available on the ground floor when needed. On the second floor were the wards for those with acute illnesses with each room having a separate bathroom to help prevent the spread of disease.

The workhouse remained in operation until 1930, when the institutions were closed down nationally. The buildings remained in use, however, becoming the Dorking Public Assistance Institution. Although similar to the workhouse in that it cared for the elderly, infirm and unmarried mothers, the function of the site was much more humane and the residents (no longer branded as inmates) could wear their own clothes and were, for the first time, allowed to come and leave the site as they wished.

DID YOU KNOW?
In February 1931, the longest-serving resident of the workhouse died. She was Miss Mary Sayers, who was born in the workhouse in 1848 and lived there for her entire eighty-three years.

In 1936, the Public Assistance Institution was finally taken over as the Dorking County Hospital. A scandal occurred in May 1939, when eighty-five-year-old Mr Ledger died in the hospital after being knocked down by a car three months previously. His funeral had been scheduled for 11 May, but just prior to the service the undertakers realised they had the wrong body. The mistake was due to the fact that there had been two bodies in the mortuary, both men of a similar age. Mr Ledger (killed by a car) was due to be buried at Cobham on the 11th and Mr Burr (killed by a train) was to have been buried at Albury on the 10th. Instead, Mr Ledger's body had been taken to the funeral at Albury and buried there. It wasn't until the next day that the error was realised and arrangements hastily arranged to postpone Mr Ledger's actual funeral, exhume his body and also to rearrange a funeral for Mr Burr.

Upon the creation of the NHS in 1948, the hospital was reamed as the Dorking General Hospital and for the first time in the 107-year history of the site all those who entered were treated equally, regardless of age, gender or social class. Later in its history, the hospital was renamed to the Dorking Community Hospital, which still operates at the site today, although much of the original buildings have been demolished. Only the ornate entrance block still survives and is now used as a nursery. The present hospital occupies the former site of the workhouse chapel, whereas the original workhouse/hospital block and infirmary have been demolished for the Downsview Gardens private estate.

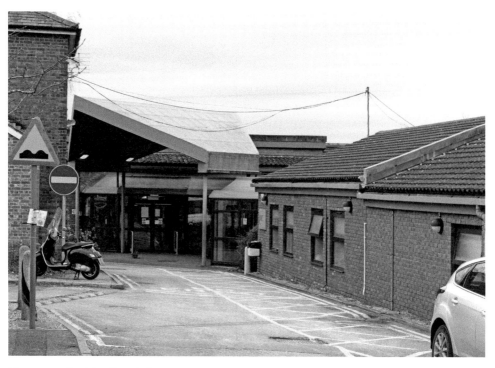

The current Dorking Hospital.

Downsview Gardens on the site of the workhouse.

Almshouses

As mentioned previously, there was originally an almshouse in South Street dating back as far as around 1617, but in 1677 new almshouses were erected at Cotmandene. In 1848 these were replaced by the present almshouses seen today, with the money coming partly from charitable donations and partly from the sale of the old workhouse. As with all almshouses, they were provided to house the elderly poor in Dorking, regardless of gender or religion, but by 1907 their future looked uncertain, since income from the charity estate had fallen to such an extent that the basic expenditure could not be met in full. An appeal was made for funds in order to prevent the trustees having to reduce the number of residents. Thankfully the almshouses were saved and the building was extended and modernised in 1961, and again in the late 1990s and still provide homes for those in need.

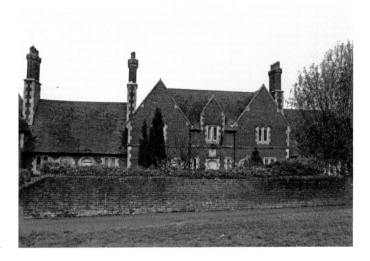

Cotmandene Almshouses.

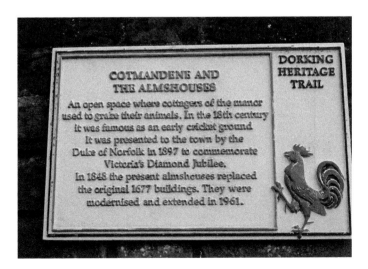

Almshouse
commemorative plaque.

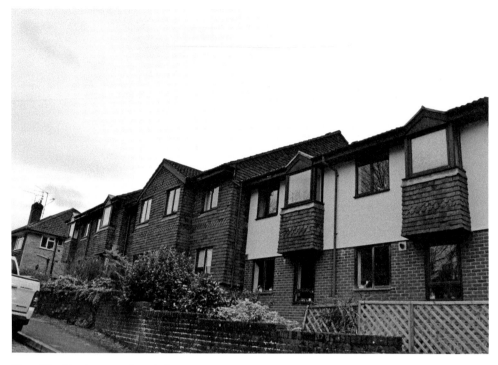

Site of Dorking's cottage hospital.

Dorking Cottage Hospital

The workhouse was not the only provider of healthcare in town. On 17 July 1871, the Bishop of Winchester formally opened the Dorking Cottage Hospital (now the site of Nos 6–10 The Pines) just off South Terrace. The building had been designed by the eminent architect Thomas Graham Jackson, perhaps best known for his work on the buildings of Oxford University.

When Queen Victoria died in 1901, an endowment fund for the hospital was set up to take donations in her memory, and by the year's end it had raised £2,050 (£160,253) to provide an additional annual income to the hospital. During that year 126 inpatients were admitted, with an average of twelve patients a week, whereas 600 outpatients had visited the hospital, and a further eighty-one people had sought dental treatment there.

In 1906 a subscription was opened to build a new operating theatre, and the number of patients steadily increased. The hospital was used to treat wounded soldiers during the First World War and was eventually incorporated into the Dorking County Hospital/ General Hospital when that opened in 1930. Like much of the main hospital, the former cottage hospital was demolished and the site is now housing.

Dorking Isolation Hospital

The idea for an isolation hospital originated in 1891 when the medical officer gave his annual report on the state of the town's health: despite a low rate of infectious diseases (although he attributed the death rate on the poor people not taking enough care of their

children), he advised that the town would never be able to tackle an outbreak without an isolation hospital.

He tried again in 1893 following a smallpox outbreak, but the health board declined, not thinking that such an institution was necessary. It was another three years before Dorking Rural District Council took up the idea of having a hospital and inquired into the possibility of providing one for the joint urban and rural district areas. In 1900 a committee had been formed and a suitable site along Logmore Lane, Wescott, had been identified. A small loan was granted to purchase the land, but still nothing was concrete. Two years passed before advertisements for the supply of furniture, bedding and caretakers for the 'temporary Isolation Hospital at Logmore Lane' were printed.

The following year and this temporary iron hospital was already proving insufficient and it took near-constant complaining before a tender was finally put out for the construction of a permanent hospital block in 1906. The need for the facility came into sharp focus in November 1907 when a severe scarlet fever epidemic hit Dorking, silencing the hospital's critics who were still questioning the need for such an institution. With the iron hospital becoming quickly filled, most victims had to be treated in their own homes, and as a result the disease quickly spread; by early December it had reached Holmwood, 3 miles away.

DID YOU KNOW?
Mary Ann Smith has the ignominious title of being the first occupant of the new cells at Dorking's second police station. She was arrested by PC Oliver for being drunk and causing a disturbance in High Street on 31 December 1894 and was taken directly to the cells for refusing to pay a fine issued by the magistrate.

Work on the permanent hospital commenced in 1908, and by 1915 the permanent hospital had been completed, consisting of six buildings, each separated from each other. It provided invaluable service during the First World War, but the war also had a detrimental effect on staffing and contractors once conscription was introduced in 1916.

In 1933 it was proposed to close the isolation hospital and convert the buildings into a convalescent home. These plans were put on hold when the Second World War broke out and the population increased with the arrival of evacuees and refugees. As the war was coming to a close in April 1945 a report was issued recommending the closure of the hospital, which finally occurred in the 1950s. Two of the buildings survive and have been converted into private residences: the nurses' house (now Meadow House and April Cottage) and the main ward block (now Merrydown and Knoll Brow).

Red Cross Hospital
At the junction of Horsham Road and St Paul's Road West is Kirkstall, a small apartment block on the site of the original Kirkstall house. In 1914 this was converted into a Red Cross

war hospital and the first patients were ten wounded Belgian soldiers on 30 October. They were only part of a larger consignment of forty-seven soldiers who were billeted around the town to recover from their injuries sustained on the frontline. Dr Morton Mackenzie oversaw the treatment at the hospital with a small nursing staff, and he was supported by Dr Dieudonne – a Belgian doctor with more experience of battlefield medicine. The hospital continued to treat wounded soldiers throughout the war and closed at the end of 1918.

The modern Kirkstall, site of the Red Cross Hospital.

4. Dorking Dilemma – The East End Foreigners

An 'invasion of Dorking' is how local newspapers branded the mass arrival of the so-called East End Foreigners in July 1917. 'Probably no country town near London has been invaded by them to the same extent' continued an article in the 21 July edition of the *Dorking and Leatherhead Advertiser*. These people were refugees from the East End of London, mostly Jews of Eastern European heritage, fleeing from the increasing German air raids over that part of the city.

For an entire week previously busses from Clapham Common had been running into town full of people seeking refuge and most of the vacant houses had been filled, leaving most scrambling for what small apartments remained. Some landlords in Dorking were dubious of these newcomers and were hesitant about letting their properties for fear that the tenants may decide to make a sudden departure without paying, particularly since many of the wealthier arrivals were keen on taking up residence close to the railway station so that they could still commute to London for work. Most people, however, were

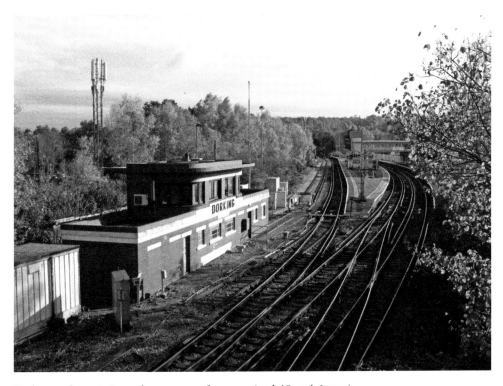

Dorking railway station, where many refugees arrived. (Gareth James)

much more accommodating and welcoming, and felt sympathy for them. In fact, these 'invaders' brought much curiosity to the locals who observed with interest what the aforementioned newspaper article called 'their continental customs. They cluster outside their doors, talking volubly, wander in groups along the streets, and sit in rows in the cool of the evening in open spaces'.

DID YOU KNOW?
In 1940, Dorking faced the very real prospect of invasion. The town's location, guarding a gap in the North Downs, made it an important defence location against the Germans and as such was heavily defended with pillboxes and tank traps and a huge anti-tank ditch was dug across the modern Denbies vineyard to meet up with the River Mole, which was also improved to make a formidable barrier.

A surviving anti-tank pimple in the undergrowth, Meadowbank Recreation Ground.

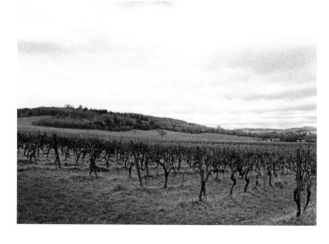

An immense anti-tank ditch scarred this landscape in 1940.

A previously unrecorded roadblock socket outside Nos 101–105 High Street.

Once the novelty wore off some genuine problems did start to manifest, most notably the availability of certain foodstuffs. This led to more animosity among less sympathetic parts of the community, and the Dorking branch of the National Union of Railwaymen took particular exception as to the shortage of sugar, which they blamed exclusively on the refugees and wealthier inhabitants of the town. The Union requested that the council took immediate steps to prevent the visitors from having 'supplied to them the goods which rightly should go to the permanent residents'.

After a lull in the air raids during August, they commenced again in late September and so began a second round of mass migration to Dorking. Most of those who had already taken up residence in town in July still remained, and throughout the summer most of the hotels were full, all houses had been rented out and the few apartments still available attracted large rents. Most of those arriving now had a hard time finding shelter, and it is reported that huge groups roamed through the town for hours desperate to find a vacancy. It is said that several of them had to spend the night in the open having failed to find shelter.

The London air raids were relentless and the refugees were still arriving in Dorking by the day. On 30 September it was necessary to open the workhouse as a temporary overnight shelter for those who were unable to secure a room elsewhere. A large room in the children's ward was made available, and beds were provided for all who needed them.

Yet more arrived in early October and the problem of shelter only grew worse. On the 1st it was decided to open a portion of the Public Hall (later fire station) as a shelter for the

night. An inquiry office was also opened at No. 12 High Street, with notices posted at the train station and on the major roads into town to direct the refugees there. Consequently, there was a continual stream of visitors to the office; each arrival would state their plight and would then be directed to the Public Hall. A little earlier, John and William Attlee (the town's millers) had opened their barn in South Street for volunteers to stuff mattresses ready for the Public Hall, and the workhouse supplied a quantity of blankets. Several of the women organised a canteen to serve hot drinks and milk, and the Temperance Hotel supplied further refreshments. Furthermore, a number of townspeople offered up their dining rooms or sitting rooms to families and provided breakfast in the morning. In total, between seventy and eighty people spent the nights of 1 and 2 October in the Public Hall; however, on the following night the demand was even greater and the Congregational Church opened their hall for the seventy additional families who had arrived that day. The families here were provided every comfort as had been afforded to those in the Public Hall, and the children were also provided with cocoa and biscuits. The Quakers also stepped in to help and were able to take in nineteen people. The situation remained the same on the nights of 4 and 5 October, and during the day the visitors would occupy themselves around the town. By this point every single vacant house and apartment had been occupied, despite rents having increased by as much as three times the standard rate, and some empty shops had also been let out for visitors to live in.

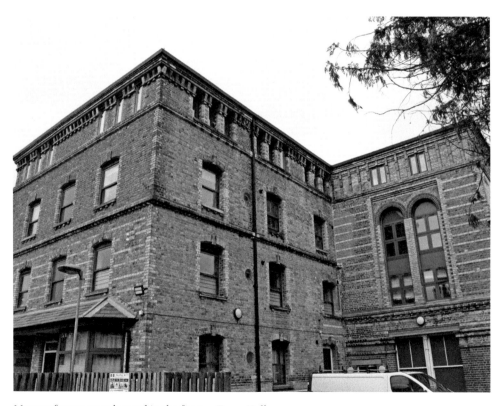

Many refugees were housed in the former Town Hall.

The refugee inquiry office was located here in High Street.

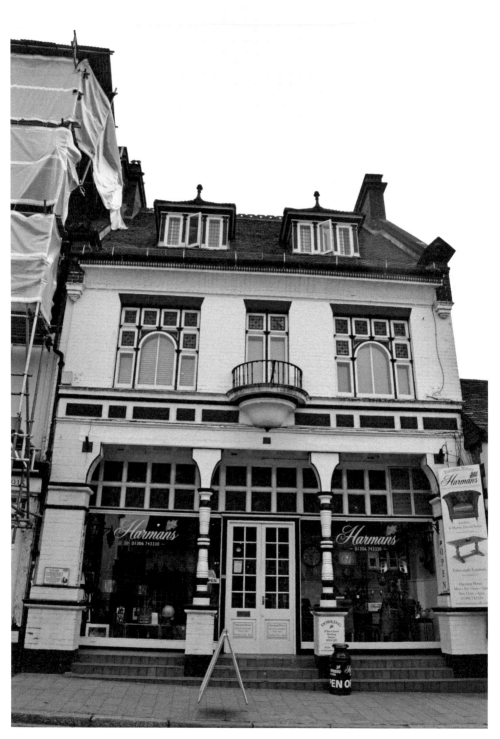

No. 19 West Street, formerly the Temperance Hotel.

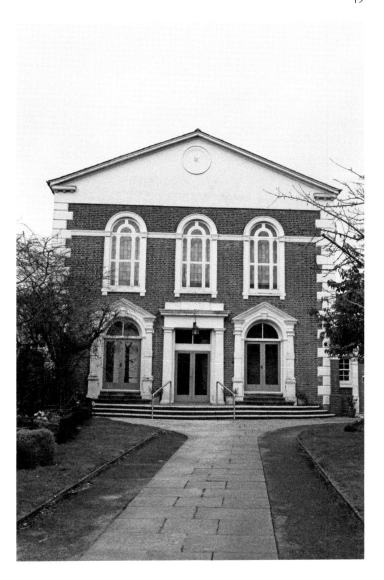

The Congregational
Church provided
emergency shelter for
the refugees.

Butter, margarine, tea, sugar and bacon were becoming very scarce, and several shops were regularly running out of stock and had to close early. Bread was another commodity that couldn't be baked fast enough to meet demand, and local regulations had to be specially relaxed by the authorities in order to allow more people to be fed.

The situation had settled by mid-November 1917, and the numbers of visitors had reduced to a sustainable level. The council did, however, draw up an emergency plan should there be any future recurrence of the 'Dorking invasion', although this never occurred. Amazingly, despite such a large influx of visitors and the cramped, confined conditions in which they had to live in the town, there had only been three cases of infectious disease; the fact that these did not spread is testament to the care the townspeople bestowed upon their temporary guests.

DID YOU KNOW?

George Tomkyns Chesney's 1871 book *The Battle of Dorking*, about a fictional German invasion of England, is widely considered to be the progenitor of the invasion literature genre, inspiring such later works as *The War of the Worlds, The Riddle of the Sands* and *The Thirty-Nine Steps.*

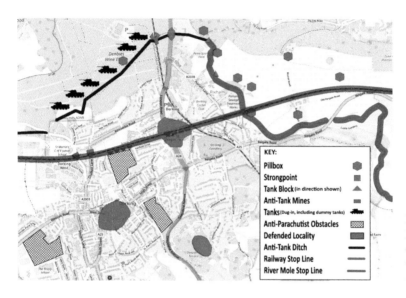

Dorking Nodal
Point, 1940,
evocative of
Chesney's story.
(OpenStreetMap)

Dorking Drill
Hall erected
in the wake of
Chesney's book.

5. Defiant Dorking –
The Conscientious Objectors

The Military Service Act 1916 introduced conscription for the first time and allowed for local tribunals to be held for men to challenge their call-up on a number of grounds, with those opposed to undertaking military service on religious, moral or political principles being known as conscientious objectors (COs).

There is no central register of COs, and so information has to be gleaned from numerous (often conflicting) sources, but in Dorking there were approximately fifteen to twenty such COs from 1916 to 1918. Five men were 'absolutists' and went to prison for standing up for their principles. This is the story of some of Dorking's COs and their struggle for peace.

Charles James Peirson

One of Dorking's Quakers, Charles was born in the town (probably at No. 16 Church Street) in 1882 to Charles James Peirson and Ellen (née Charman), who had married at Horsham's Quaker Meeting House in 1876. His mother was originally from Brighton Road, Horsham, and his father – a Londoner – worked as an ironmonger, a career that Charles junior would also enter.

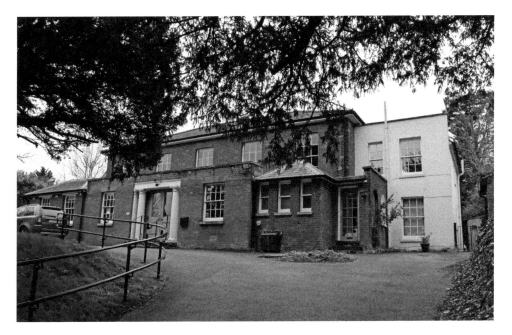

The Quaker Meeting House.

Charles appeared at the Dorking tribunal on 26 June 1916, by which time he was residing at Ingleview, Cliftonville. He tried at first to apply for absolute exemption but would accept a non-combatant role. The tribunal ordered that he join the Friends' Ambulance Unit, which he did on 24 September. Volunteering for overseas service, Charles was posted to the Queen Alexandra Hospital in Dunkirk as an orderly, and he remained stationed there until discharged in April 1918.

This hospital was relatively small, at its peak having room for 200 beds at the Villa St Pierre and in a number of huts and tents in the villa's gardens. It was not a safe environment to work in, becoming a frequent target for German artillery and aerial bombing – so much so that a large dugout was created in the grounds as a shelter. During

Ingleview, Cliftonville, home to one of Dorking's COs.

the German Spring Offensive of March–April 1918 (the time that Charles was discharged) the hospital came in for extremely heavy bombardment and was forced to evacuate. Was Charles injured during this time, leading to his discharge? Unfortunately, the surviving records do not say. He returned to England and was later awarded the Victory Medal and British War Medal for his services.

Samuel Francis Peirson

Younger brother to Charles, Samuel was born at Dorking in 1891 and attended the Dorking High School for Boys between 1902 and 1904. Like his brother and father, he also joined the ironmonger trade, and a few years before the war had moved to Reading. However, by 1914 he had returned to the family home – No. 16 Church Street.

He began the war as a CO and volunteered to join the Friends' Ambulance Service as an orderly in November 1914 and was sent to the Queen Alexandra Hospital at Dunkirk soon after. He continued in this role for three years, but perhaps being exposed to the German bombardments (which in September 1917 had been particularly heavy) and seeing the effects of the attacks, something must have changed in Samuel's mind, and he left the unit on 12 November in order to return to England to take up a commission as a lieutenant in the Royal Army Service Corps. Unfortunately his service records do not appear to have survived, and his medal index card is blank. However, two medals – the 1914 Star and British War Medal – engraved with Samuel's name and unit were sold at auction in 2017.

Site of No. 16 Church Street, home of the Peirson family.

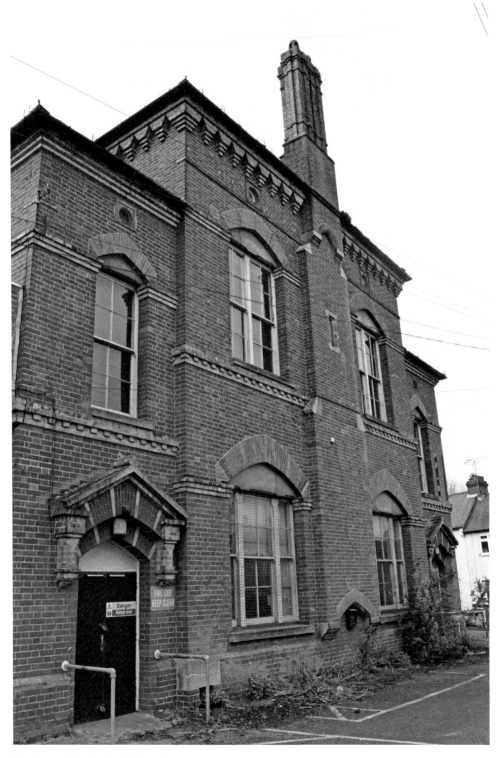

The former boys' school, Dene Street.

Samuel never married, and after the war he returned to Reading, where in 1939 he was working as a timber merchant. He died in 1973 in Eastbourne.

Dr John Rickman

Another of Dorking's Quakers, John was the only child of Richard Peters Rickman and Caroline Ann (née Marsh); Caroline was the sister of Edward Harold Marsh – another of Dorking's COs who volunteered for the Friends' Ambulance Unit. Richard Rickman died when John was only two and the latter was brought up by his mother at No. 22 Rose Hill. The family must have been fairly wealthy, since Caroline was able to support the family on her own means, as well as employing domestic help.

When war broke out in 1914 John was undergoing training to become a doctor at St Thomas' Hospital. He graduated in 1916 and was one of the four original COs to be called up to Dorking's first tribunal on 8 March 1916. As a pacifist he applied for total exemption from military service, arguing that his interpretation of his faith made it impossible to join any military body and that disputes should be solved through reconciliation rather than violence. He claimed that he had been a CO since he took part in a school debate on the matter of conscription at the age of fourteen in 1905, but would be willing, once he had finished his studies, to help in hospital work so long as he was not forced to join the Royal Army Medical Corps. The tribunal (which was largely hostile to the concept of conscientious objection) could not understand his refusal to join the RAMC, but granted John a six-month exemption from military service.

No. 22 Rose Hill, childhood home of Dr Rickman.

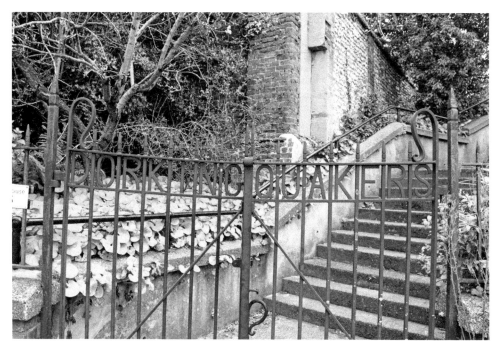

Several of Dorking's COs were Quakers.

John appealed this decision and on 9 August was before the Dorking tribunal once again. This time he was granted a conditional exemption so long as he took up work of national importance on or before 8 September 1916. As such, he volunteered with the Friends' War Victims Relief Service, which worked to alleviate the suffering of displaced and injured civilians across Europe, and was posted to the Samara region of southern Russia.

Despite having little equipment, food or other resources, let alone support from governments or outside agencies, John and the small group of other volunteers offered medical support to the Russians. In 1917, he met an American volunteer, Lydia Cooper Lewis, and after the region fell to the Bolsheviks in the October Revolution, the pair married. As the civil war grew worse they had to flee the region and, after a perilous three-month journey on the Trans-Siberian Railway, managed to escape to Vladivostok. Passing through Japan and the USA, he managed to return to England and worked in the psychiatric ward of Fulbourn Hospital, Cambridge. In 1920 he travelled to Vienna to work with Sigmund Freud and throughout the 1920s and 1930s continued to work in the field of psychoanalysis across Europe. During the Second World War, Dr Rickman started out working as a psychiatrist in hospitals, but in 1942 joined the RAMC – which in 1916 he had refused to join – in order to treat soldiers returning from the war suffering from PTSD. He died in 1951 having devoted most of his life to psychoanalytical medicine.

Arthur Tomlinson

Although being another of those cases where the historical record has gone cold, Arthur Tomlinson (of No. 58a South Street) deserves a particular mention on account of being

Site of No. 58a South Street, home of Dorking's first CO.

the very first person in Dorking to officially declare himself as a CO, at a tribunal on 8 March 1916. He worked as a ledger clerk at a flour mill and requested total exemption – combatant or non-combatant – since his beliefs would not permit him to take any part in the war effort, or support anyone else to take part in war. The tribunal did not know how to take Arthur and had a hard time in distinguishing between the concept of non-violent self-defence and killing someone; they dismissed his claim.

He appealed the decision and put his case before the Surrey County tribunal in April, though he was once again dismissed outright. It is not known what ultimately became of Arthur, but one source indicates that he was eventually given a conditional exemption.

Charles Edward Tritton

One of Dorking's absolutists, Charles and his brother, William, suffered at the hands of those who sought to quash the COs. He had been living at No. 6 Hampstead Road when he was arrested in late May 1916 for failing to respond to his call-up, and was brought before the Dorking Police Court on a charge of being an absentee from his unit. The arresting officer, Police Sergeant Lightfoot, claimed that Charles told him that he did not intend to obey any orders.

At his trial, he said that he was only trying to live up to the highest standard he could and when the law of God contradicted the law of the nation, then he would always choose the former. Unfortunately for Charles, the magistrate hearing the case had lost his son, Lt C. S. Harding, in August 1915 and took great exception to Charles' position and interpretation of his faith. Charles was fined and remanded in custody to await a military escort to the Non-Combatant Corps (NCC).

No. 6 Hampstead Road, former home of Charles Edward Tritton.

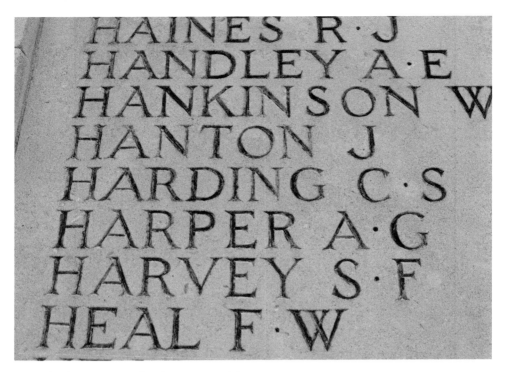

Lt Harding's name on Dorking's war memorial.

Charles was 'accepted' as a private into the 10th Border Company NCC on 29 May at Seaford Camp (the word 'enrolment' was struck out on his attestation form and the word 'acceptance' pencilled in, indicating the fact that Charles had been forced into the situation, rather than volunteered). Sticking to his principles, he was sentenced to fourteen days detention on 30 May for refusing to obey an order. Shortly after his release, Charles was in trouble again on 16 June for being absent from parade, although he avoided another spell in detention on this occasion.

Three days later and Charles was again in the guard room waiting to be subjected to his first court martial on 26 June, where he was handed six months imprisonment with hard labour for refusing to obey orders. The final fifty-six days of his sentence were remitted and he was admitted into Maidstone Prison on 1 July. Upon release, Charles was transferred to the 4th Eastern Company at Coventry, but was soon placed in the guard room to await trial by court martial on 10 November for once again disobeying an order. This time he was handed 112 days imprisonment with hard labour at Wormwood Scrubs. The story repeated itself at Dublin on 21 February 1917 and on 1 March he was sentenced to two years imprisonment with hard labour (commuted to one year) for the same offence and was sent to Mountjoy Prison on 5 March to carry out his sentence.

Having served almost a full year, Charles was released early on 4 January 1918, but was once again in the guard room on the 8th and sentenced to a full two years with hard labour in Liverpool Prison at a court martial held on 10 January. He served just over four months before being released on an order from the Home Secretary on 27

May and transferred to the Class W Army Reserve for men 'whose services are deemed to be more valuable to the country in civil rather than military employment'. This likely meant that after suffering in prison for so long, Charles agreed to enter a Home Office work programme as a civilian carrying out either agricultural or forestry work, after the government had introduced this programme in order to reduce the number of COs in prison. Like many other COs, Charles was among the last to be finally discharged and 'freed' from the military authorities on 31 March 1920 – two years after the Armistice, and long after the 1919 Treaty of Versailles had been signed to officially end the war.

William Alfred Tritton

William's story was similar to that of Charles. He was among the first four of Dorking's COs to face the tribunals on 8 March 1916, where he asked for total exemption based on the fact that he believed all war to be wrong and contrary to the interests of mankind, a 'foolish ... method of attempting a settlement of national or racial difficulties'. He went on to explain that war achieved nothing but land the country with debt and spread hatred. William refused to undertake any work that would assist in the prosecution of the war, believing that the highest form of work of real national importance was to forward the cause of peace and goodwill and the tribunal could not persuade him otherwise – they dismissed his claim outright. William appealed to the county tribunal on 29 March to reaffirm his convictions and was granted exemption from combatant service only.

On 5 May, Police Sergeant Lightfoot visited William at No. 6 Hampstead Road, since the latter had not reported himself to the Borough Hall at Guildford after receiving notice to do so. William did not respond and was arrested and taken to Dorking police station. The next day he was in front of the magistrates on a charge of being an absentee from his unit. The military representative told the court that William was sent his notice to join the 16th Royal Fusiliers on 10 February and again on 25 February after the first notice went unanswered. William had by this point lodged a claim with the Dorking Tribunal and then the appeal tribunal as stated above. Leave to appeal further was refused and William had been ordered to report himself immediately to the military authorities. On 3 May, William did pay a visit to the recruiting office in Guildford but only to refuse to enlist. He was presented with another notice ordering him to report again the following day, but he did not show up and was arrested on the 5th. William was prepared to face the consequences of sticking to his convictions and offered no challenge to the charges against him. The magistrates fined him £2 (£117.98) and handed him over to the military to await an escort.

On 6 May William was taken to Guildford and was 'accepted' (not 'enrolled') as a private into the 3rd Eastern Company NCC. On 23 May William was in the guard room to await trial by court martial, which took place on 2 June. Unlike Charles, who had a series of smaller sentences for refusing to obey orders, William was immediately hit with two years imprisonment with hard labour, although this was later commuted to 112 days, and he was sent to Lewes Prison to serve out his sentence. While in prison, William was transferred to the 4th Eastern Company on 13 June, but the remainder of

his records did not survive the German bombing of the Second World War. It appears that William was another absolutist and had to endure the unfavourable conditions in prison for standing up for his beliefs and principles at a time when society was not ready for such convictions. William moved away from Dorking after the war and died in Nottingham in 1960.

DID YOU KNOW?
In September 1918 the wife of an unnamed CO living at Rough Rew Lodge on Ridgeway Road applied to the War Pensions Committee (run by the workhouse's Board of Guardians) for financial assistance after her husband, an absolutist, had ended up in Wormwood Scrubs Prison. The Guardians refused to offer help since they did not consider her to be destitute nor chargeable to them.

Edwin Turner

Born in Crawley in 1878 to Edwin Turner and Catherine (née Brooker), Edwin was not originally a native of Dorking. In 1891 the family was living at Coldharbour Cottage, Bletchingley, before moving to Lingfield by 1901, when Edwin had his own home and was working as a coachman. A decade later, Edwin had become an insurance agent and had returned to Bletchingly to live at Bank Buildings as a boarder with William and Ellen King. Interestingly, two of the Kings' children, George Arthur King and William Kenneth King, would serve in the First World War and Edwin had already by this time become a CO.

By the time of Edwin's appearance at the Dorking tribunal on 10 July 1916 he was residing at No. 5 Rothes Road with his wife, Susan (née Smith), and son, Godfrey Edwin Turner, and had been promoted to the assistant superintendent of the Pearl Assurance Company. He also worked at the Baptist church, and ran the weekly Sunday school for the children. He applied for a conditional exemption based on his conviction that it was wrong to take a life under any circumstances, even in self-defence, and was contrary to his religious beliefs. He didn't object to non-combatant duties so long as it was used for the saving of life and didn't require serving in the military, since this would violate his conscience by undertaking 'unnecessary work on the Lord's Day' while in training. He also objected to using or bearing arms, or to participate in the use of arms in any dispute. He told the tribunal that he would wish to undertake work of national importance (particularly with the Red Cross), except for making munitions, even if it would result in a reduction in his present salary and require giving up his home – sacrifices he and his wife were both prepared to make in the national interest. Contrary to the case of Samuel Francis Peirson, who began as a CO and then joined the army, Edwin Turner began as a soldier before becoming a CO – a story he related at the tribunal. He had volunteered with the City Imperial Volunteers during the Second Boer War, a short-lived force that was involved in the Relief of Kimberley in February 1900. He now considered it was wrong of

No. 5 Rothes Road, once home to Edwin Turner.

Dorking's Baptist church in 1916. (The Voice of Hassocks)

him to have taken up arms. The tribunal granted an exemption from combat service. It appears that Edwin appealed this decision at the Surrey County Tribunal on 22 July, but his case was dismissed.

He was accepted into the 7th Eastern Company NCC on 24 August 1916 at Guildford. Unfortunately, his service record is in a poor condition, with only three badly damaged pages surviving and so no further information about what happened to him during the war could be found.

After the war, Edwin, Susan and Godfrey moved to Reigate, living at No. 63 Blackborough Road in 1939 and he was still working in the insurance industry. Edwin died at Reigate in 1941, aged sixty-three.

Arthur Woodland

The last of the 'Dorking Four' original COs, Arthur Woodland was born in Dorking in 1881 and joined his father's stonemasonry business at No. 25 West Street by 1901, a job he continued to have when in front of the Dorking Tribunal on 8 March 1916. At this tribunal, he applied for total exemption based upon his religious beliefs, believing warfare to be wrong and contrary to the teachings of Jesus and would therefore be 'unlawful' for him to take part in fighting or assisting others to do so. When questioned on the matter of helping the wounded, Arthur stated that he would object on the basis that it would be releasing other men to fight. After continued hostile questioning, the tribunal finally granted an exemption from combatant service only. On appealing to the County Tribunal (the same hearing as William Tritton) he attempted once more for total exemption, but his case was dismissed.

As an absolutist, Arthur did not report himself to the recruiting office and on 20 May had the by now familiar house visit from Police Sergeant Lightfoot. At the magistrates' court it was revealed that Arthur's father had desired that he joined the army, but respected his views and his conscience, and so Arthur accepted that he must accept the

Dorking Cemetery, where Arthur Woodland is buried.

consequences of his beliefs, although he was apologetic for the 'trouble' he was giving the magistrates by having not enlisted as requested. He wasn't fined, but he was remanded to await a military escort. Arthur was 'accepted' as a private into the Non-Combatant Corps at Guildford on 20 May.

Arthur was posted to the 3rd Eastern Company and quickly found himself in detention three days after his enlistment. His court martial took place on 1 June and, like William Tritton, was immediately sentenced to two years imprisonment with hard labour for disobeying the command of a superior officer. This was commuted to 112 days and he joined William Tritton at Lewes Prison on 5 June 1916.

On 1 November 1916, after nearly five months in prison, Arthur accepted a transfer to the Home Office work programme and was transferred to the Class W Army Reserve. He spent the rest of the war carrying out this work until he was finally discharged on 31 March 1920 having served almost four years with the Non-Combatant Corps. Arthur returned to Dorking after his eventual discharge, but he didn't live much longer and died in early 1926 aged forty-four. He was buried at Dorking's Municipal Cemetery on 23 May 1926.

6. Deep Dorking – Tunnels, Caves and Bunkers

Many towns and villages have rumours of tunnels, often being little more than a local legend of a smuggler's hide. However, Dorking's tunnels are very much real, and the town seems to be riddled with various underground spaces hidden beneath our feet. Some of these are well known, such as the South Street Caves, whereas others are perhaps a little more secretive, such as the Deepdene bunker.

Despite being a familiar local attraction, the South Street Caves (the only underground features now open to the public) are still shrouded in a great deal of mystery. It is generally thought that the caves – or more accurately tunnels – were excavated in the seventeenth century, principally owing to references in later eighteenth-century works and the presence of graffiti in the caves dating back as far as 1666. Although there were several entrances into these caves, all but one has been blocked. The entrance today (on special arrangement with Dorking Museum) is via a non-descript green door beside the war memorial, which leads to the large upper level, consisting of a system of four interconnected tunnels forming a rough square in plan under Victoria Terrace and South Street, the corners of which align with the compass directions. Along two of these tunnels are nineteenth-century wine vaults dating to approximately 1815, which were used by the local tradesmen Mr Cheesman and Messrs Young. These caves were renowned for the preservation of liquors since they offered a year-round stable environment. One of the tunnels leads to a narrow stone-cut staircase wending its way some 40 to 50 feet further underground to the 'lower mystery chamber' – a round 'room' lined with a carved stone bench and sporting a domed ceiling. There have been rumours and legends of this space being used by secret societies or persecuted religious orders (probably due in no small part to the similarity to Royston Cave in Hertfordshire), as well as the standard stories about smugglers found in most towns and villages in the south-east. It is likely, however, that the room was carved simply as an underground folly to entertain guests – with one popular story being that the cave's excavator spent his entire fortune on digging out the tunnels before ending up in the workhouse. Another reason for the deeper level could be revealed in a 1787 book on Dorking, which refers to a 'fine crystalline spring of water' at the bottom of the staircase. Since many other tunnels under Dorking were likely originally excavated to extract building sand, this may also be the origin of the South Street Caves.

As the war clouds loomed over Europe in early 1939, attention turned towards providing air-raid shelters in Dorking. Members of the council were advocating the digging of deep, bomb-proof shelters, though this motion was defeated. However, one member, Mr Bell, suggested that the 'miles of underground tunnelling' beneath the town could be adapted into natural shelters at relatively little expense. Although this gained support of other members, it was not taken any further owing to the counter argument that delayed-action bombs could penetrate deep into the earth and therefore turn the shelters into a

Entrance to the South Street Caves.

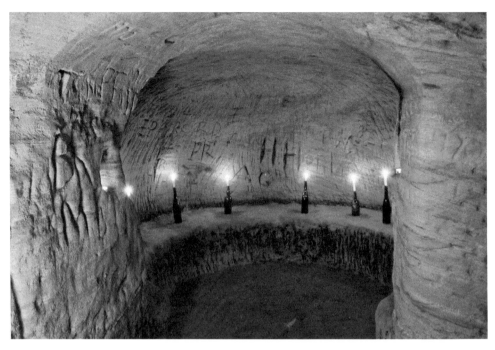

The so-called 'Lower Mystery Chamber'. (Sam Dawson)

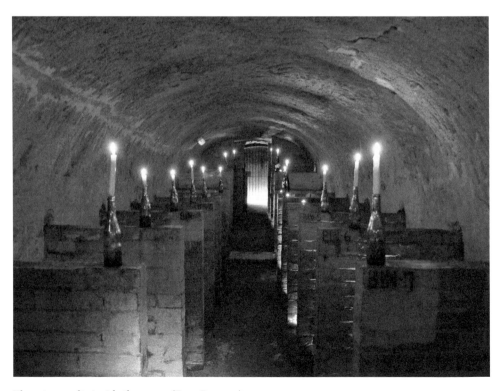

The wine vaults inside the caves. (Sam Dawson)

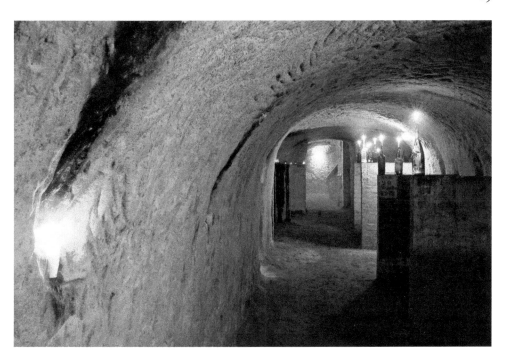

Inside the South Street Caves. (Sam Dawson)

death-trap with no escape. Once war broke out the subject of providing shelters was back on the agenda. The council agreed to erect twelve surface shelters around the town, but it was Mr Bell who again raised the issue of the caves; although they were never officially sanctioned for use as shelters, many people in the town sought sanctuary in the caves during the numerous long alerts that were issued throughout the war years.

As mentioned above, the South Street Caves are far from being the only ones under Dorking's streets. In 1884 the district surveyor was concerned about the scale of mining under High Street as property owners excavated sand or created cellars under the road. He was particularly concerned about the stability of the road in front of the Wheatsheaf Inn (now Nos 37–39 High Street) where there was only some 15 feet of earth between the road and the roof of the tunnels underneath. However, at this time the owners of property had a right of ownership of the land in front of their premises to the halfway point of the road. The council did not think there was any safety issue, despite the surveyor warning about the weight of traction engines passing over the tunnels, and resolved only to notify the owner of the pub about the danger of extracting the sand and his liability if anything should happen.

An entrance to a pair of tunnels can also be seen at Castle Mill, another set of caves exists behind the present Dorking Baptist Chapel off High Street and at Deepdene there are a number of 'very large' folly caves. It was at Deepdene, once the seat of the Dukes of Norfolk, that Charles Howard created the Italianate gardens. As part of this landscaping, he attempted to have a tunnel dug through the hillside, but the subsurface geology was too unstable and it collapsed. The entrance was quickly blocked up and converted into a grotto.

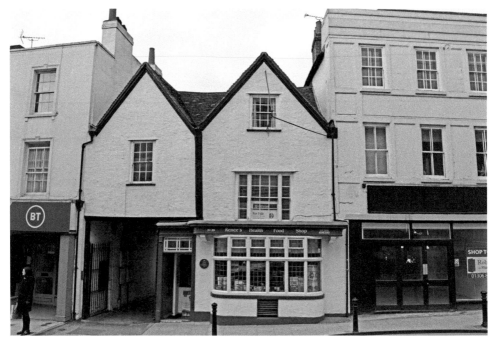

The former Wheatsheaf Inn, High Street.

DID YOU KNOW?
Hidden in woodland close to the A24 at Holmwood was a Royal Observer Corps post. This small underground bunker for two or three men was fitted with equipment to detect nuclear blasts and monitor radioactive fallout. It opened in the 1960s and remained in use until closed in 1991. It has since been demolished. At the same time as the bunker was in operation in the 1960s, the Solartron research lab at Goodwyns Place designed and made prototype electronics equipment for use in Polaris nuclear missiles.

Entrance hatch to an identical ROC bunker at Billingshurst.

Deepdene is also home to another underground structure of much greater importance. In the Second World War, Southern Railway took over Deepdene as its wartime headquarters and it was decided to use the 300-year-old folly caves to construct a large secret underground bunker. Three separate entrances from the caves led into a series of chambered rooms, roughly square in plan, of which some were used to house a telephone exchange, switchboards, meeting rooms, bedrooms and toilets. From the telephone exchange was a long passageway at the end of which was the air ventilation system and a spiral staircase up to the emergency exit concealed in some nearby woods.

The bunker and Deepdene House remained in use until the early 1960s. The house was demolished in 1969 and a modern office complex was built on the site. The bunker was later found to be heavily contaminated with asbestos in the 1990s and as a result all entrances were securely sealed. The bunker's purpose was to provide a safe emergency headquarters from where Southern Railway could manage the rail network and make any arrangements necessary for diversions due to bomb damage.

DID YOU KNOW?
Dorking was home to other secret wartime headquarters, such as the Special Operations Executive training school at Bellasis House at Box Hill. It was from this house that Jozef Gabčík and Jan Kubiš were sent to carry out Operation Anthropoid – the assassination of SS-Obergruppenführer Reinhard Heydrich – in December 1941, as popularised in the 1975 film *Operation Daybreak*. Denbies was also occupied as a Home Guard training school.

Denbies was used as a national Home Guard school.

There are dozens of other tunnels and underground spaces dotted across Dorking, mostly hidden under many of the town's older buildings. I heartily recommend Sam Dawson's excellent book *Dorking: A Town Underground* for a more detailed exploration of this subject.

DID YOU KNOW?

In August 1887 a 100-yard section of the Betchworth Tunnel collapsed seconds after the Horsham train had passed through. Bricks were seen falling from the ceiling before it totally collapsed. A similar event killed several men at the same spot during the tunnel's construction in 1867. The tunnel and railway remained shut for over six months before it was repaired.

The Betchworth Tunnel, site of several collapses. (Colin Smith)

7. Disastrous Dorking – George Green and the RMS *Titanic*

George Green was from a large family, being the ninth of eleven children of Ned Green and Mary (née Ranger) when he was born at Falmer in 1871. Ned Green had originated from the small village of Rodmell, around 3 miles south of Lewes, where he was born in 1825. He appears in the 1841 census under the name Edward Green and living at Rodmell with his parents, Robert and Elizabeth, and eight of his siblings. Mary Ranger was also a native of Sussex, having been born at Tarring Neville (just north of Newhaven) in 1833. She, too, appears in the 1841 census (at Tarring Neville) with her parents, Thomas and Susanna, and five siblings. Both families were employed in the agricultural trade.

By 1851, Ned (still called Edward in the census) and Mary were living at Lodge Farm, Piddinghoe, where they both worked as servants – Mary as a house servant and Ned as a groom. They married the following year and by 1861 had moved to Falmer, where Ned (having now dropped the name Edward) was working as a carter and the couple had four children: William, Thomas, Philip and Susan. In 1871 the family were all still living at Falmer, but with the addition of four more children: Henry, Elizabeth, Charlotte and Mary. George first makes an appearance in the 1881 census with his parents, brother Henry and sisters Mary, Emily and Sarah Ann.

By 1891 George had moved out of the family home and gone to live with his brother, Thomas, at Cliff House in Cuckfield. Ned and Mary remained living at Falmer until Mary died in 1904 and Ned in 1908. In 1891, George and Thomas Green were both working as the village blacksmiths. Ten years later, George had moved back down to the coast, boarding at No. 16 Blackman Street, Brighton, the home of Samuel J. Farrow (a lavatory attendant) and his wife, Eliza Farrow. By 1901 George Green was living at Dorking and working at Mr Smithers' forge in Ansell Road, marrying Theresa Janet Morris at St Martin's Church on 25 December.

Theresa had been born at Coventry in 1869 and in both the 1871 and 1881 censuses she was living at No. 14 Craven Street, Coventry, with her father (Nathaniel, a watchmaker), mother (Martha, a silk weaver) and several of her siblings. In 1891 the family were residing at The Knob, Hearsall Lane, Coventry, where Theresa had joined her father's profession working as a watch balance maker. She left the Morris household by 1901, when she appears as a domestic nurse at Middleton House, Upper Bognor Road, Bognor; the household was a large one, consisting of John L. Watson (a school principal), six members of his family, an assistant, four pupils and two other servants.

George and Theresa had their first child, Hilda, on 30 July 1902 at Dorking. Their second child, Kathleen, arrived on 19 August 1905 and their third and final child, Olive Janet Green, was born in 1907. They were all living at No. 1 Lyons Cottages, Dorking, at the time of the 1911 census – just a year before George died. Hilda and Kathleen both attended St Paul's Church of England School, with Hilda leaving in August 1910 and Kathleen on

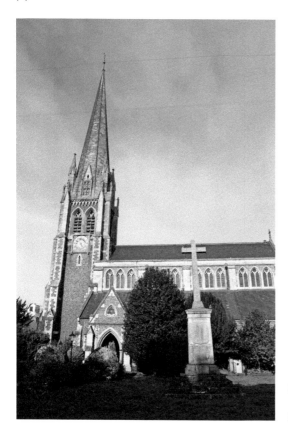

Left: St Martin's Church.

Below: Site of No. 1 Lyons Cottages.

3 April 1912, just seven days before the *Titanic* set sail. An interesting note appears beside her entry in the logbook: 'Gone to United States'. This wasn't quite true, however, since George Green boarded the ship alone with a third-class ticket (No. 21440) on 10 April 1912 – a ticket that placed him deep down in the ship, barely above the waterline.

The first news of George's fate appeared in the 20 April 1912 edition of the *Dorking and Leatherhead Advertiser*, which carried a brief article reporting that 'There is every reason to fear that a Dorking man is among the victims.' He had intended to begin a new life in Lead City, South Dakota, and the article relates that the night before the ship departed Southampton, George had sent a postcard of the *Titanic* to his colleagues at the Ansell Road forge. For reasons not entirely known, Theresa and the three children had

St Paul's School.

Former Ansell Road forge.

Several products from
the forge can still be
found today.

left Dorking a few days beforehand to stay with her parents in Spon Street, Coventry,
intending to follow George across the Atlantic a few weeks later on the *Titanic's* next
voyage – their bags had all been packed in anticipation. By 23 April the family still had not
received any news of George and so had to assume that he had gone down with the ship.

DID YOU KNOW?
Another *Titanic* passenger was a man named Edward Arthur Dorking. He survived
the sinking and toured the American theatres with his story of the disaster. He
went on to survive both world wars as a soldier in the American Army.

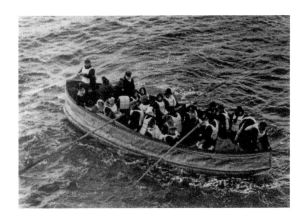

Survivors of the *Titanic* being rescued. (NARA)

Edward Dorking's name on the survivor's manifest. (NARA)

As motorised vehicles had started to become more commonplace, George's trade was suffering and he took the opportunity to travel to America to find a better life for his family; a work colleague from the Dorking forge had previously made the voyage and had made a success of his new life. The two men had maintained correspondence ever since, and the family had decided to follow this example. In another tragic twist, shortly before the *Titanic* sailed, Theresa had tried to persuade George to postpone the voyage so that he could spend a week in Coventry to meet his in-laws for the first time, taking another ship at a later date.

On Easter Tuesday 1912, the house at No. 1 Lyons Cottages was disposed of and the family left Dorking for Reading. At this place, George said his goodbyes and set off for Southampton. Theresa's brother had intended to travel down to greet George at Southampton to say his own farewell, but an ongoing coal strike prevented him from

being able to do so. Theresa had received several telegrams from George sent during the voyage, and on the night of 14 April – when the ship was sinking – Hilda had just finished writing a return telegram to her father. In addition to the postcard George had sent to his friends in Dorking, he had sent an identical one to his father-in-law, and another to Theresa's brother, signing off with the message 'Lovely sailing. George'.

For around a year prior to George's departure, he had been suffering some ill health and as a result had spent almost all his savings on healthcare. This left Theresa and the children with no means of sustaining themselves and she had to appeal to the Lord Mayor's Fund for finance. At some point Theresa had moved back down to Surrey, where she died in 1962 aged ninety-three. It is not known if George's body was recovered and he has no known grave.

DID YOU KNOW?
There was another person aboard the *Titanic* with the name George Green. He was an engineer in the ship's crew and also died in the sinking. It is similarly not known if his body was recovered and so has no known grave.

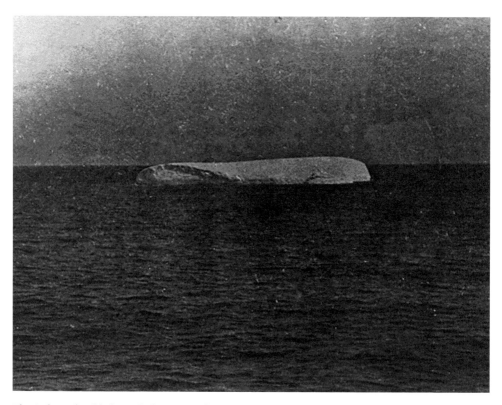

The iceberg that likely sunk the *Titanic*. (NARA)

8. Dramatised Dorking – On the Big and Little Screens

The Dorking area has been chosen by film directors as a location for more than seventy films and television productions for over eighty years. Unfortunately, there is not the space available to take a look at each one and so only those filmed in the town itself will be included.

The first production was the now lost 1931 crime drama *Lloyd of the C.I.D.* The final scenes were filmed at Deepdene House in early October 1931 and it follows Detective Lloyd as he attempts to apprehend a villain known as The Panther. After its original release as twelve half-hour episodes in January 1932 it was re-edited into a single one-hour feature film called *The Green Spot Mystery*. The last known broadcast of the original series was on Swedish television in July 1974, since when both the serial and the later film have been lost.

This was followed in 1939 by the comedy *Ask A Policeman*, which follows the escapades of three incompetent policemen in the village of Turnbotham Round. The village had been free of crime for a decade when the chief constable informs Sergeant Dudfoot that the station will be closed. The three start to fabricate crimes to try and stop this, beginning by setting up a speed trap outside the village and end up attempting to frame a driver for an accident; the driver turns out to be the chief constable. After narrowly getting away

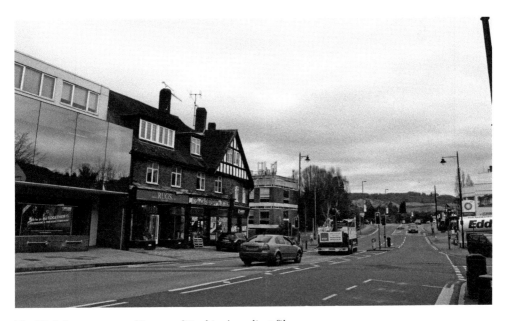

The High Street appeared in one of Dorking's earliest films.

with the incident following a stranger's false witness statement the three policemen plot to invent a smuggling ring. This ends up backfiring as they discover an actual smuggling gang operating out of the station's cellar. The smugglers trap the police in their own cells, but they escape and a lengthy, calamity-laden road chase ensues firstly in a car, then a motorbike and sidecar, and finally in a double-decker bus. Dorking appears briefly during this chase as the bus follows the smugglers' lorry along High Street just past the old police station and courtrooms, towards the A24 roundabout. The film ends at Brooklands where the three reveal the truth behind the incident at the start of the film to the chief constable, who orders their arrest. Sergeant Dudfoot punches him and the three run along the racetrack to make their escape.

Dorking's Castle Mill featured in the 1956 episode 'The Haunted Mill' of *The Adventures of Robin Hood*, and again in the 1957 episode 'The Road in the Air'. Then, in 1962 it starred in *The Avengers* episode 'Build a Better Mousetrap'. After two elderly sisters living at a watermill claim to cast a spell on a gang of bikers riding on nearby land, Steed investigates as every other mechanical device in the area similarly fails and suspicion at first falls on a local nuclear plant. However, after learning of the issue with the motorbikes, Steed begins to place his attention on the mill, eventually discovering that the sisters have a secret jamming device concealed inside – a device that another gang also has its eyes on. Although filmed in a studio, the exterior of Castle Mill is used to portray Vernon Watermill (even though the sign 'Castle Mill Dorking' can be clearly seen in the shot).

DID YOU KNOW?
Since 1948 there have been seventeen other productions filmed in the wider Dorking area, such as at Leith Hill, Coldharbour and Betchworth. These include such well-known titles as *Casino Royale*, *Four Weddings and a Funeral* and *Doctor Who*.

The 1993 romantic drama *Century* starred Clive Owen as a Jewish doctor (Paul Reisner) working at a medical research institute headed by Charles Dance's character, Professor Mandry, in late 1899. Although at first being hugely supportive of Mandry's work, Reisner grows weary of the professor after learning that he is a keen eugenicist and has been forcibly sterilising working-class women. The two men's differences of opinion and ethics continue to escalate until Reisner is suspended from the institute. Dejected, the doctor befriends Clara, a worker at the institute played by *Blackadder's* Miranda Richardson, and the pair quickly develop a passionate relationship. Cotmandene appears in the film's opening and closing scenes during a celebration to welcome the start of the new century. The ornate exteriors of Nos 3 and 4 Rose Hill also star as the fictional 'Glen View, Elm Hill, Dorking', the home of Reisner and his father. The young Reisner leaves for London in the rear of a horse-drawn carriage along Rose Hill and under the arch at Butter Hill as his father follows to give a drawn-out farewell.

The Cotmandene featured prominently in *Century* and other productions.

Nos 3–4 Rose Hill acted as the home of Dr Reisner.

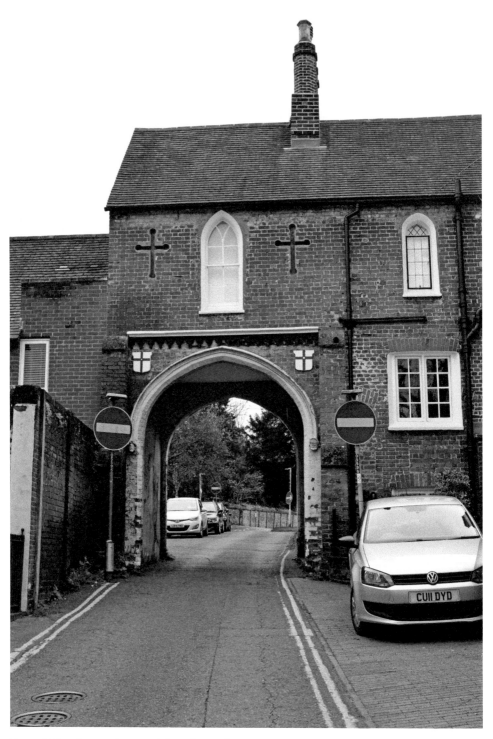

Butter Hill arch, site of Reisner's long farewell scene.

In the very first episode of *Foyle's War* in 2002, the detective investigates the murder of a German woman while investigating corruption affecting the internment of enemy aliens. Despite being set in Hastings, Flint Cottage in Mickleham is used as a doctor's cottage and later in the episode Foyle and his son, Andrew, are fly-fishing in a river, which is actually the River Mole behind Castle Mill.

In 2013, for the first time Dorking was used exclusively as the setting for a production, in the dark five-part BBC thriller *Mayday*. The overall plot centres around the disappearance of the town's teenage May Queen, Hattie Sutton, as she is on her way to the festivities, leading to mutual suspicion among the townsfolk that someone among them is responsible. The first episode opens with a panorama over Dorking from Ranmore Road, followed by Hattie cycling down a twisting, heavily wooded road before cutting to the footpath off Chequers Place and then north along Rose Hill. Suddenly Hattie jumps to Calvert Road and continues along the footpath beside the Pixholme Grove allotments, heading under the two railway bridges; at each stage she is observed by suspicious-looking characters who later become the key suspects. Her abandoned bike, wheel still spinning, is found beside the railway bridge at the end of Lincoln Road. The drum-led May Day procession heads up Heath Hill and on to Cotmandene, where the onlookers observe that Hattie is missing from her throne at the head of the procession.

The footpath to Rose Hill, an early location in *Mayday*.

The footpath where Hattie is last seen alive.

Hattie's abandoned bicycle was found in Lincoln Road.

As the search for Hattie begins, and the police start to question members of the community, the suspicion grows, setting brother against brother, son against father and wife against husband. A search party comes across an area of woodland known as the 'Magic Circle' and find Hattie's garland. Steve (Hattie's uncle), who has arranged both the festival and search party, suspects his brother, Seth, whom he witnessed entering the woods earlier in the day. Meanwhile, former policewoman Fiona (whose daughter found Hattie's bicycle) suspects her husband (a serving officer) after finding blood on his clothes, and Gail Spicer discovers that her husband, a property developer who has been spending much time in the woods of late, has spent all of the family's money on a proposed new estate that Hattie had been successfully leading protests against. Linus, a teenager with a crush on Hattie's twin sister, Caitlin, finds his father, Everett, has been harbouring something heavy in a large bag and is violently attacked when he tries to investigate further. Fiona also starts to grow highly suspicious of Everett and ends up finding Hattie's clothes in a lake near the Magic Circle.

Later, Fiona's husband finds Hattie's body hidden in a tree in the woods, and although Seth confesses to her murder, more suspicious links with, and between, the other characters emerge. In the finale each character is proven innocent one by one until the real killer is revealed: Alan the policeman, who believed Hattie to have been a witch who had put a spell on him.

DID YOU KNOW?
In 1966 two episodes of *The Baron* filmed two very dramatic car crash scenes at Betchworth. The first saw a white Jaguar plummet over the top of the Betchworth Quarry cliffs, while the second featured a red Renault in a similar cliff plunge. These scenes became famous in their own right and featured in no fewer than twenty-eight productions around the world over the next thirty years, including in episodes of *The Saint, Randall and Hopkirk (Deceased), Saturday Night Live, Spitting Image* and *Father Ted*.

Of the many familiar locations around Dorking that can be picked out are the Denbies View Veterinary Centre on Westcott Road, the Dene Street flats, West Street, the exteriors of Mystery Fountain and the Sea Breeze kebab shop in Dene Street, the Sheephouse Green estate at Wootton (where Linus and the Sutton family live), No. 2 Rose Hill (the Spicer family home), the Ashcombe School (where Hattie, Caitlin and Linus attend) and the former magistrates' court on London Road stood in for the town's police station; Pippbrook House became the base for the production team for the twelve-week shoot.

Victoria Terrace made a very brief appearance in the 2014 comedy *Breaking the Bank* about an incompetent banker (Charles Bunbury) played by Kelsey Grammar, who tries to save his wife's family business from international banking corporations. Failing in a risky gamble, he loses the bank and his wife, and plots to try and win them back. After

86

Hattie's vacant throne ascended Heath Hill, indicating something wasn't right.

No. 2 Rose Hill, used as the Spicer family home.

Dene Street flats, another location used in *Mayday*.

Victoria Terrace makes a brief appearance in *Breaking the Bank*.

a desperate phone call from a bedraggled Charles, Penelope is seen leaving a house in Victoria Terrace and walking down towards South Street. She is followed by a limousine driven by Andrew Sachs and a shrewd American investment banker (Richard Grindling) tries to get her on side. Despite threatening Richard with a conveniently located brick found outside Seymours Estate Agents, he manages to persuade Penelope to join him and the pair drive away.

Most recently, two series of the Channel 4 comedy *Home* have been set in Dorking and follows the life of a middle-class family who, on return from Calais, discover that a Syrian asylum seeker has hidden in their car, having got lost and separated from his family. Ironically, although supposedly set in Dorking, it was mostly filmed elsewhere: the family home is in Kingston, the church is actually All Saints in West Ewell, the 'Dorking Surgery' is really the Capelfield Surgery in Claygate and 'Raj's Corner News' is a mid-terrace newsagents in Alexandra Drive, Surbiton (also the location of other 'Dorking' shops). Some scenes were, however, filmed at Dorking, including at Denbies and on Box Hill.

DID YOU KNOW?
Not only was Dorking used as a filming location, but it was the birthplace of one of the UK's most famous actors. Laurence Olivier was born at No. 26 Wathen Road in 1907 and spent the first three years of his life there.

No. 26 Wathen Road, birthplace of Laurence Olivier.

9. Dynamic Dorking –
The Stranger Side

When researching for a book it is quite common to come across anecdotes and stories that help shine a very different light on a place. Here, then, we will take a look at some of these fascinating and quite unusual tales from Dorking's past that have by and large remained hidden from the mainstream history so far written about this wonderful Surrey town.

1925: Frederick Charles Booth VC – A Hero's Downfall

From humble beginnings, Fredrick Charles Booth had a very distinguished career in the South African Forces during the First World War. Born in North London in 1890, he was just short of his twenty-seventh birthday when he undertook the action that led to his Victoria Cross in February 1917. Soon afterwards, he was awarded the Distinguished Conduct Medal and was then mentioned in despatches in September 1917. He was wounded shortly after and invalided back to England.

However, on 8 July 1925 Frederick's wife, Dolores, applied to the divorce court on the grounds of cruelty. Dolores had been widowed with two children when she married Frederick, whom she had known for a while, and they lived together at The Lodge, Effingham Place, Effingham. It was alleged that after the marriage Frederick developed a violent temper and drank heavily, sometimes striking his wife. Giving one example in February 1922 Dolores' counsel specified the time when the couple were out driving in their Rolls-Royce and, after she had made a casual observation, Frederick hit her in the mouth. On another occasion it was stated to the court that after Dolores had made a comment, Frederick pinned her against a door and repeatedly punched her, and in May 1922 it was alleged that another incident occurred during a meal out in Hyde Park. The couple moved to Phillamore Gardens, Kensington, and in October 1922 had their first child together. Two weeks later Frederick threatened to leave Dolores and the child, but did not do so in the end; however, in November he acted violently once more. The court dismissed the petition.

At Dorking Magistrates' Court on 7 October 1925, Frederick summoned five servants at Effingham Lodge and Inspector Frederick Lightfoot (whom we first met as a police sergeant in chapter 5) for assault. Despite still being legally married, the pair had been living apart – Frederick at Kensington and Dolores at Effingham. In September, Dolores received a message from Frederick that he was coming down to visit her. Although she attempted to prevent this from happening, due to the state of the law at the time she had no lawful right to restrain Frederick from entering any house she was living at, even though it was her own separate legal property; Frederick visited on 17 September and, finding the door open, entered the house. At the court, Frederick accused Inspector

The former courthouse, scene of Captain Booth's court case, 1925.

Lightfoot of having 'stage managed' a situation so as to lead to his ejectment from the house, since after a few minutes Dolores' chauffer entered the room and asked him to leave. Almost immediately after a maid entered the room to make a similar request, and she was followed in turn by the cook, who threatened to phone the police if Frederick did not leave. Dolores then entered the room and ordered her husband to leave. Frederick informed all present that if they so much as touched him he would summon them for assault, to which Dolores replied that she would gladly pay their fines. It is alleged that Inspector Lightfoot (who was also present) said 'it is only a common assault, go on chuck him out,' to which advice the chauffer and cook obeyed. Frederick, however, managed to knock both men down and was eventually forcibly removed by the groom, chauffer, cowman, two gardeners and Inspector Lightfoot; four of the men were each fined 1s (£2.05) for common assault. Meanwhile, Dolores had filed a cross-summons against Frederick for using threats and he was bound over in the sum of £50 (£2,052.95) to keep the peace.

Over the course of the month, Frederick was unable to find employment and appears to have lost his Kensington home. Dolores made him an offer of £4 a week (£164.24) if he would leave the country, but he refused to do so. On 31 October 1925, having become destitute, Frederick entered the Dorking Union Workhouse

with just a farthing in his possession; he was there for six days before the Board of Guardians ordered his discharge for the following morning – apparently, according to Booth, because the Guardians wanted him 'to clear off'. Speaking to a journalist on the morning of his removal from the workhouse, Frederick suggested that he was going to seek a friend in Dorking and travel to London to find work. If not, he would be back in the workhouse again by nightfall. Aside from his discharge, Booth had stated that his treatment in the workhouse had been 'perfect', that he was treated no different to the other inmates and that he hoped he had not caused any unnecessary trouble. One of the Guardians stated that the actual cause for Booth having to leave the workhouse was that he was an able-bodied man. Within hours of his arrival back in London Frederick had received several offers of employment and shelter. Details of his life after this time are patchy: in 1939 he was living with his personal secretary in Folkstone, and he died on 14 September 1960 in Brighton, being buried four days later at the Bear Road Cemetery.

1947: A Botanical Mystery

During the Second World War six German bombs landed harmlessly in some woodland on Brockham Hill, leaving behind a series of craters 30 feet in diameter. They were soon forgotten about as the war ended, but in 1947 some strange plants were spotted growing in one of the craters. At first they bore resemblance to native species: one looked like a sunflower, but with very large leaves, and another appeared similar to a foxglove, but grew on a 6-feet-tall stem. Stranger still was that none of the twenty-five species of plants identified were known to have been cultivated in Britain before this point. The discovery was kept a secret, but expert botanists flocked to the area in 1950 and reported that these plants were all from South and Central Europe. At first it was thought that the seeds of these plants had somehow become mixed into the bomb's explosive, or otherwise became stuck to the bomb casing, and survived the blast. This was thought unlikely owing to the variety of the seeds, ranging from northern Greece, Yugoslavia and Austria, and that they grew in only one of the six craters on Brockham Hill. Another theory was that migrating birds were responsible, but this was also discounted owing to the large variety of plants and the extremely localised growing pattern in the crater. It was decided to leave the crater alone in order to see if the plants would spread, but within a month it was reported that very few remained – either they had been dug up by gardeners wanting something a little different or otherwise the non-native species were unable to withstand the onset of the British autumn.

DID YOU KNOW?
In the early 1950s, a nuclear test bomb was almost accidentally dropped on Dorking. Although it did not contain any nuclear material or explosives, the 5-ton device became detached in the aircraft's bomb bay over the town and could still have caused considerable damage if it had fallen on the streets below.

A Vickers Valiant almost dropped a bomb on Dorking! (RuthAS)

Brockham Hills, site of a botanical mystery. (David Howard)

1970: When Dorking Was an IRA Target

When six London men were in the dock at the Old Bailey in March 1971, it was revealed that they were members of the IRA and had planned to bomb a factory near Dorking. The factory in question was the Schermuly Ltd premises at Ewood Farm near Holmwood. This company had been designing and manufacturing various rockets and other projectiles for decades and in the late 1960s had been making and packaging CS Gas weapons being used in Northern Ireland.

The group were plagued by informants and Special Branch kept a watch on their headquarters at Drakefield Road, Tooting, where three of the conspirators resided. Using listening equipment, the officers could hear the men discussing bomb making and through a pair of binoculars saw containers with the labels 'sulphuric acid' and 'sodium chlorate'. When the property was raided, police found further bomb-making equipment and instructions. Each man was sentenced to between two and three years imprisonment for being in possession of bomb-making equipment and on charges of intent to cause an explosion.

DID YOU KNOW?
Captain Christopher Hussey, who was born in Dorking in 1599, was one of the founders of Nantucket, Massachusetts. He is also a direct ancestor of former President Richard Nixon and Meghan Markle, Duchess of Sussex.

Above: William Mullins' plaque, another of Dorking's New World settlers.

Right: Mullins' house, the only surviving home of a Pilgrim Father.

1996: A Legal First

On the morning of 19 February 1996 a car arrived outside Dorking Magistrates' Court and out stepped an eighty-five-year-old retired carpenter dressed in a fur coat and flat cap. His name was Szymon Serafinowicz, a resident of Banstead, and his case was to mark an historic moment in British legal history: he was the first person to be tried for war crimes in the UK.

Serafinowicz was born in modern-day Belarus in 1910 and became a police chief during the Nazi occupation, later coming to the UK as a refugee after the war and settling in Banstead. He was arrested first in 1995 on accusations of allegedly murdering three Jews between 1941 and 1942 around the Minsk area, and sixteen witnesses testified during his twenty-two-day committal hearing at Dorking, which had been postponed for over a month to allow the witnesses to travel from the USA, South Africa and Israel. Serafinowicz strongly denied the claims and pleaded his innocence throughout.

DID YOU KNOW?
The Robert Dyas shop in the High Street contains wall paintings dating back to the reign of James I (1603–35).

One of the charges was dropped by the magistrates, but they ruled that there was indeed sufficient evidence to commit the elderly and ailing man to trial at the Old Bailey on the remaining charges. Serafinowicz never made it to trial, however, since in January 1997 an eight-day hearing ruled that he was suffering from dementia and was therefore unfit to stand trial (although the prosecution's expert witness claimed that he was fabricating the symptoms). Serafinowicz died a matter of months later on 7 August 1997, and was buried at All Saints Church, Banstead, with his wife (who had died in 1993) and one of his sons (who had died in May 1997). He and his supporters maintained his innocence throughout. Around £8 million had been spent on the case before it collapsed.

Dorking Magistrates' Court, scene of Britain's first war crimes trial. (Paul Gillett)

Image Credits

A Handbook of Dorking (public domain): Engravings of St Paul's Church and Denbies (chapter 2), Market Hall and view from railway station (chapter 3).

Colin Smith: Betchworth Tunnel (chapter 6).

David Howard: View of North Downs (chapter 9).

Gareth James: Railway station and signal box (chapter 4).

National Archives and Records Administration, Washington DC (NARA): *Titanic* survivors, passenger manifest and iceberg (chapter 7).

Paul Gillett: Magistrates' Court (chapter 9).

RuthAS (CC-BY-3.0 https://creativecommons.org/licenses/by/3.0): Vickers Valiant (chapter 9).

Sam Dawson: South Street Caves (chapter 6).

The Voice of Hassocks (CC0 public domain): St Barnabas' Church (chapter 2) and Baptist Church (chapter 5).

OpenStreetMap contributors: Maps (introduction and chapter 4). Data contained is available under the Open Database Licence and the Creative Commons Attribution-ShareAlike 2.0 licence, both available at www.openstreetmap.org/copyright.

Bibliography

A large number of sources were used in the research for this book, including:

Books
Dawson, Sam, *Dorking: A Town Underground* (Dorking: The Cockerel Press, 2019)
Dennis, John, *A Handbook of Dorking* (Dorking: 1855)
Timbs, John, *A Picturesque Promenade Round Dorking in Surrey* (London: 1823)
Winchester, Clarence (ed.), *The World Film Encyclopedia 1933* (London: The Amalgamated Press, 1933)

Newspapers and Magazines
Dorking and Leatherhead Advertiser
Surrey Advertiser
Surrey Comet
Surrey Mirror
West Surrey Times
The Bioscope, No.1305, Vol.LXXXIX, 7 October 1931
The Bioscope, No.1306, Vol.LXXXIX, 14 October 1931